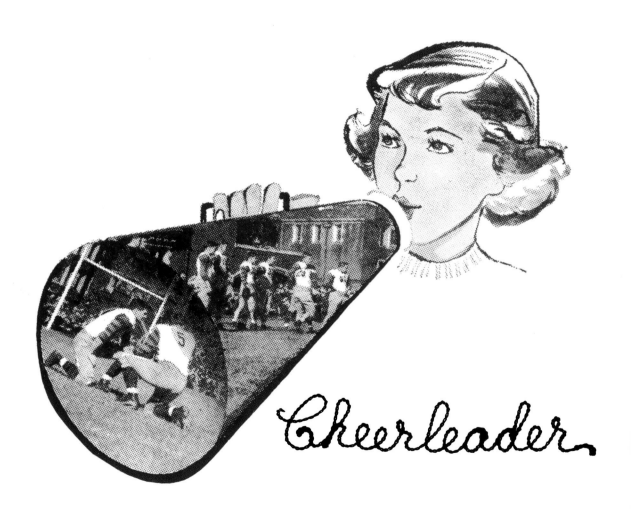

Cheerleader

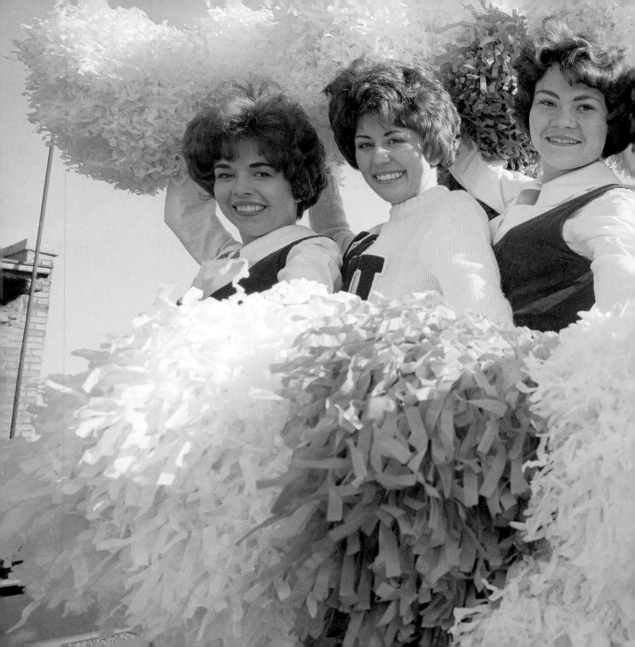

Cheerleader

Ready? Okay!

By Elissa Stein

CHRONICLE BOOKS
SAN FRANCISCO

Gimme a **C**!

Copyright © 2004 by Elissa Stein. All rights reserved. No part of this book may be reproduced in any form without written permission from the publisher. Page 124 constitutes a continuation of the copyright page.

Library of Congress Cataloging-in-Publication Data:
Stein, Elissa.
 Cheerleader : ready? OK! / by Elissa Stein.
 p. cm.
Includes bibliographical references.
 ISBN 0-8118-4127-8
 1. Cheerleading—United States—History. I. Title.
 LB3635.S84 2004
 791.6'4'0973—dc21
 2003009484

Manufactured in China

Book and cover design by Benjamin Shaykin

Typeset in News Gothic, Century Expanded, Antique Central, Hoboken High, and Rockwell

Distributed in Canada by Raincoast Books
9050 Shaughnessy Street
Vancouver, British Columbia V6P 6E5

10-9-8-7-6-5-4-3-2-1

Chronicle Books LLC
85 Second Street
San Francisco, California 94105

www.chroniclebooks.com

To the gallant men and women whose courage and determination . . . whose bravery and sacrifice . . . whose devotion to an ideal . . . have secured for future generations of our people the right and privilege of assembling to laud the feats of skill, acts of daring, displays of resourcefulness, and manifestations of teamwork that underlie the structure of a great free nation.

—Newt Loken, *Cheerleading and Marching Bands*

And to Jon, Isabel, and Jackson . . . who inspire me at every turn.
—Elissa Stein

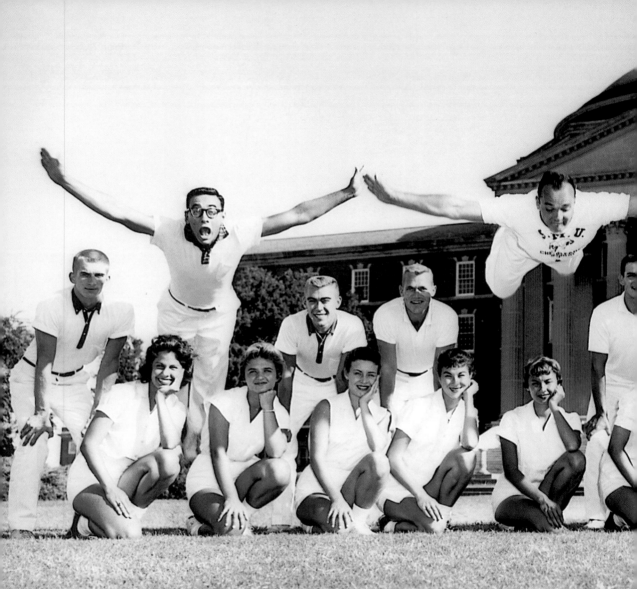

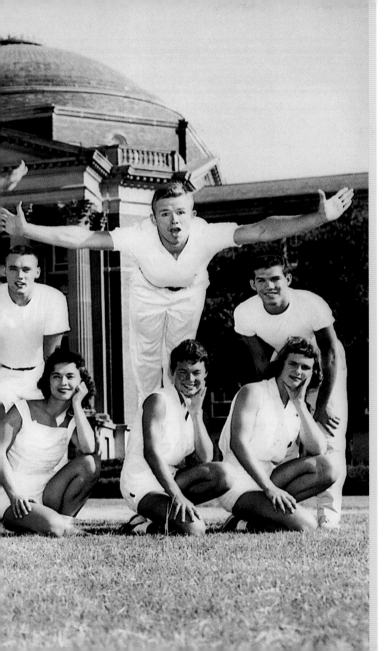

CONTENTS

INTRODUCTION

It's the last quarter, the team is down, the field is awash in mud and muck. The crowd is discouraged, the players exhausted. Some folks are already making their way out of the stands when the cheerleaders bound onto the field—a squad of six girls, smiles on their faces, a spring in their steps—despite the weather, despite the dismal score. They assemble in formation. Pom-pons poised at the hip, they shout out *"Ready? Okay!"* and launch into a cheer . . .

Be aggressive. B-E

BE
RES

BE AG

aggressive.
AGG
A
SIVE
RESSIVE!

It's infectious. The crowd joins in, and the players rally, mustering what it takes to win the game. Shouts of *"Go team!"* ricochet around the field as fans shout into megaphones, waving team banners overhead. *"Okay! Let's take it away!"* yell the cheerleaders from the sidelines, thrilled by a last-minute touchdown. The fans roar as the squad leaps into the air, finishing off their victory cheer.

CHEERLEADERS—loathed by some, loved by the REST OF US.

Those pleated skirts. The matching sweaters. The pom-pons, megaphones, and bobby socks. These girls really have it all.

Today, the tradition of cheerleading spans the globe. There are junior high school squads, high school squads, professional squads, college squads, and squads that cheer just for the thrill of it. *Cheerleader: Ready? Okay!* harkens back to the heyday of cheerleading—back when opportunities for girls in organized sports were few and far between—when cheerleading for girls was tantamount to football for boys. And even though they weren't competing on the field, these girls trained just as hard as the athletes they cheered on.

THE HISTORY OF CHEERLEADING IS FULL OF SURPRISES. You may be shocked to learn that in the early years of cheerleading, boys made up the squads. It wasn't until the 1920s that girls were allowed to join in. And that's when cheering really skyrocketed in popularity. Organized squads gave girls a chance to partici-pate in sports and take center stage, showing off their athletic prowess, rhythm, and spirit.

As cheerleading gained in popularity the stakes grew higher. Not only did making the squad take athletic ability and a perky smile, but personality played

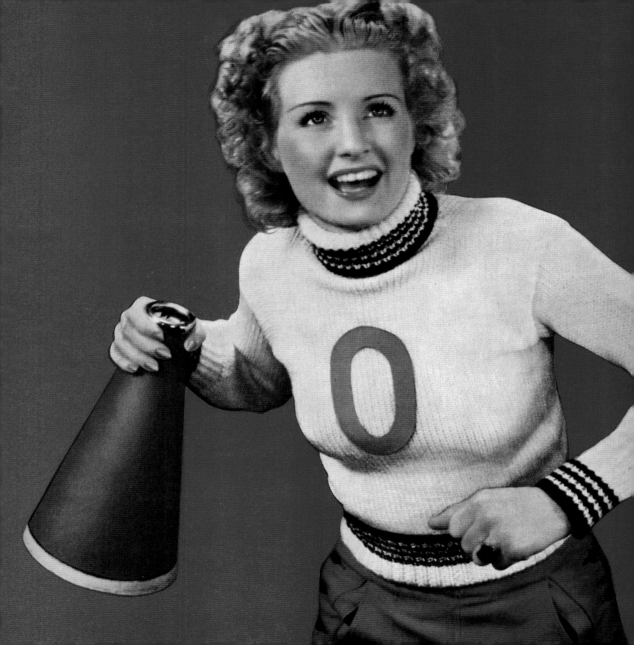

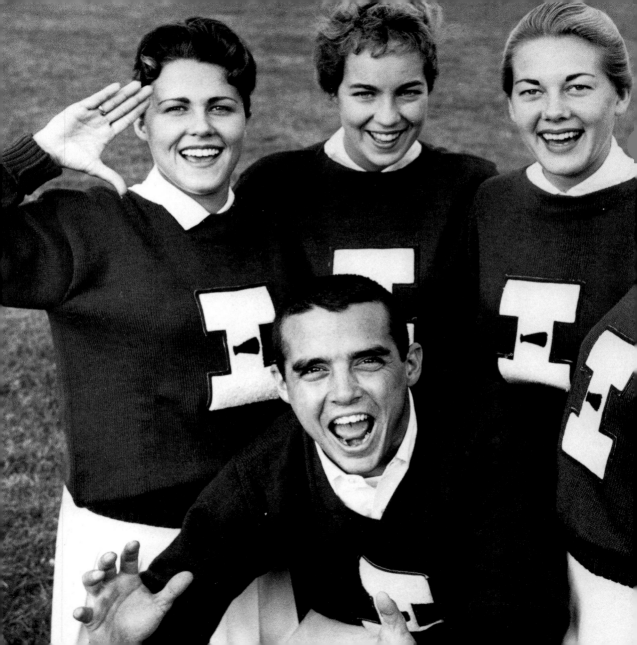

a large part as well. We are all familiar with the iconic image of a cheerleader—*wholesome, friendly, and peppy*. A cheerleader is a highly visible school representative. Winning one of those coveted spots means joining the inner circle—and wearing that cute uniform. It's no wonder that to this day cheerleaders elicit strong emotions, from love and admiration to envy and disdain.

By the mid-1940s, it seemed like everyone wanted a uniform and a moment in the spotlight, not to mention an excuse to exhibit unabashed school spirit. Sporting events hosted booster clubs, drill teams, pep squads, song leaders, majorettes, pom girls, marching bands, mascots, and flag corps—all part of the game-day spectacle.

In that era, pop culture couldn't help but hop on the cheerleading bandwagon as well. Movies and TV programs loved to feature cheerleaders—those popular girls next door whom nearly every boy wanted to date and nearly every girl wanted to be. Cheerleader cut-out dolls, coloring books, and comics topped every girl's wish list. Cheerleader dolls, complete with letter sweaters, swingy skirts, and miniature poms, filled store shelves. And cheerleaders were an advertiser's dream. Who could possibly resist the allure of those radiant girls, ponytails bouncing in the breeze? Advertisers used cheerleader images to promote every product under the sun. *Shaving cream! Engine oil! Phone service! Cereal! Sweaters! Car stereos! Ice cream! Coca-Cola!* Cheerleaders lent a wholesome flavor to nearly any item. If a cheerleader believed in the product, then so would the public at large, or so the thinking went.

We're still fascinated by cheerleaders. Whether their hair is slicked back in a ponytail or styled in a bouffant; whether their skirts reach their ankles or are shockingly short; whether they're waving homemade paper poms in the air or performing elaborate stunts—we're mesmerized.

Ready? Okay!

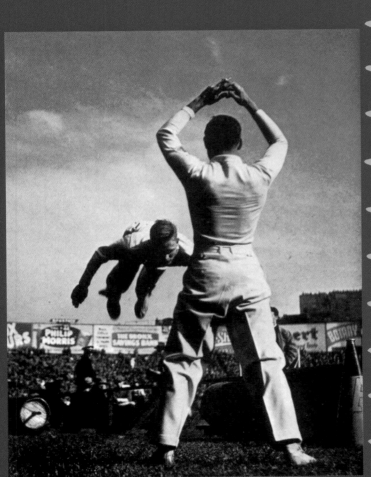

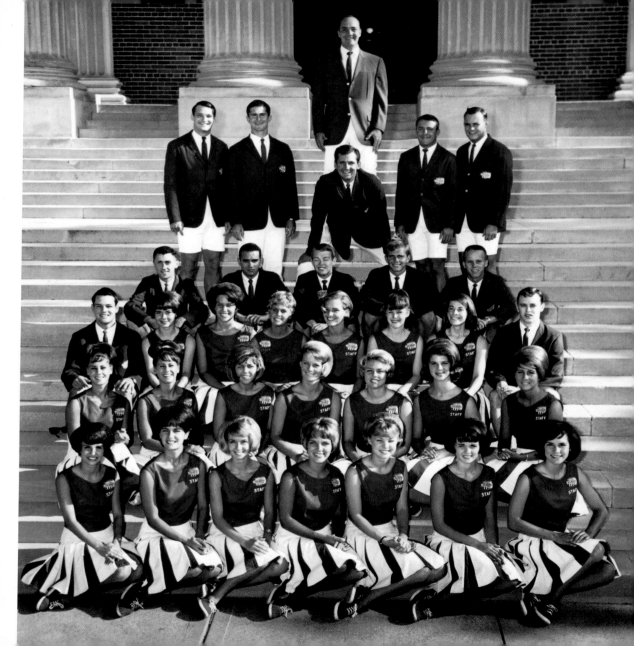

THE **H**istory OF *Cheerleading*

CHEERLEADING HAS A RICH AND STORIED HISTORY. Before pom-pons, pyramids, and pleated skirts, cheerleading belonged to the boys. Yes, the boys. In dapper white slacks and coordinated sweaters, megaphones in hand and acrobatic stunts rounding out their repertoire, all-boy squads lined the fields from Tucson to Tuscaloosa. But by the 1920s, with the advent of the suffragette movement and new-found freedom for women, girls soon took to the field, and boy, did they sparkle. With rhythm, style, and *much* cuter uniforms, girls gave the boys a run for their money. For years girl squads reigned supreme, but today with high-stakes competitions and increasingly difficult stunts and choreography, coed squads are once again all the rage.

From those long-ago fall afternoons in the Northeast, when the very first cheerleaders chanted *"rah, rah, rah!"* into their megaphones, to today's highly athletic coed squads, cheerleaders have come quite a long way from the bow-tied boys who started the tradition.

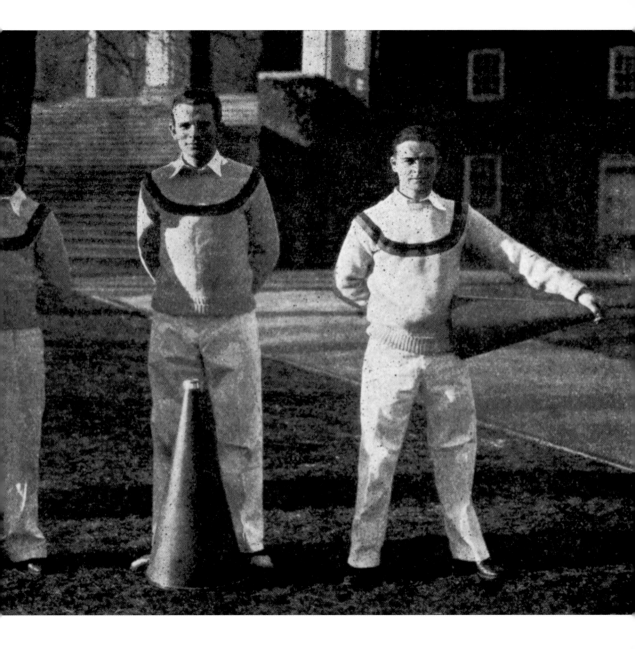

The Mid-1800s

It's hard to imagine a high school football game without cheerleaders leading the crowds in cheers and chants. It's even harder to imagine public schools without girls in the classrooms. But in the late 1800s, higher education, including public high school, was generally available only to well-off young white men who were lucky enough to have the funds to spend on education. With time on their hands and energy to burn, students filled their weekends with football and other sporting events. The tradition of cheerleading began with outgoing spectators who yelled encouragement from the sidelines.

In the 1860s, Princeton students galvanized school spirit and created the country's first original college cry. They chanted:

HOORAY, HOORAY!
TIGER SIS, BOOM, AAH
PRINCETON

It was the first official cheer noted at a football game. Princeton lore credits the Seventh Regiment of New York City with the inspiration for this original yell. Those union soldiers roared their "sis, boom, aah" at the Princeton depot on their way down to Washington to fight in the Civil War. Local students adapted that hearty cry, and soon it was heard at every game. Legend then has it that Thomas

Peebles, a Princeton graduate, brought the yell and pep concept west to the University of Minnesota. There, in 1898, a first-year student by the name of Johnny Campbell took cheerleading into his own hands. At the last game of a horrible football season, Johnny leapt to his feet, grabbed a megaphone, and yelled:

RAH RAH RAH!
SKI-U-MAH
HOO-RAH
VARSITY!

His voice rocketed around the field. The crowd embraced the cheer, and by the next season, Campbell and five fellow students formed the first-ever cheerleading squad.

HOO-RAH! VARSITY! MINN-E-SO-TAH!

The 1910s

Cheerleading spread quickly to other colleges and high schools, and the honored position of yell leader, or rooter king, became quite coveted. Students elected the yell leaders. The most popular, charismatic, and personable young men on campus won spots on the squad. And they did it all—acrobatics, tumbling, and stunts, along with fight songs and cheers—keeping fans' attention riveted on the field.

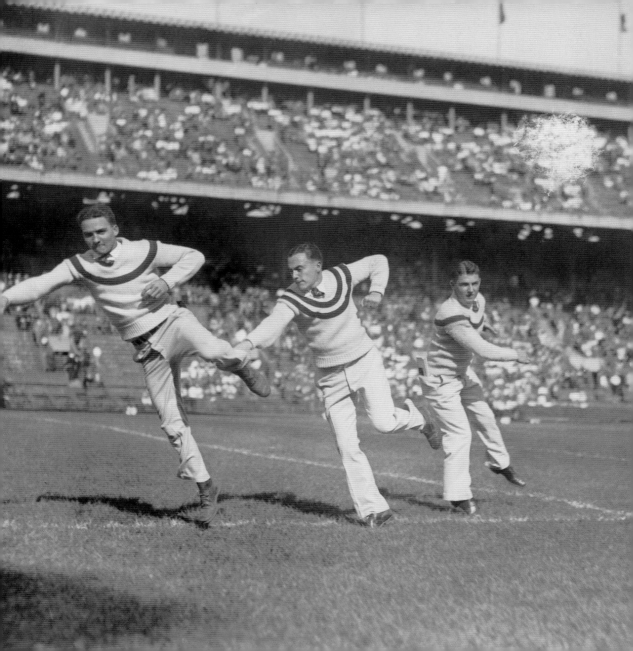

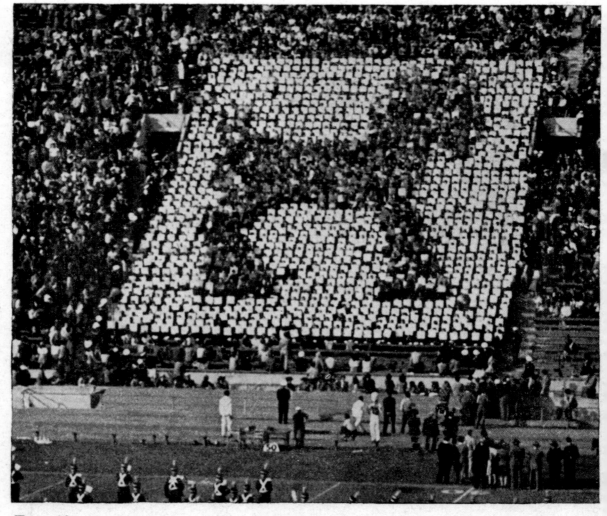

cheerleader

FIG. 40

Southern California's student flash-card section, an illustrious example of an organized cheering group, forms with cards of varying colors a Trojan horse —the school's symbol.

The 1920s

By 1923, the first cheerleading class, a four-week course in stunts, crowd psychology, and perfecting yells, appeared at Purdue University. In 1927, *Just Yells*, the first cheerleading book ever published, signified cheerleading's growing popularity. High schools and colleges from around the country contributed cheers, chants, and rally ideas. University leaders wrote eloquently about the psychology of crowd control and effective cheers.

Around this time a truly innovative phenomenon swept across California—flash-card sections. Picture this: two thousand or so students sitting together in the bleachers, each with a stack of colored cards. At their leader's direction, they'd flash the cards in unison, creating tremendous graphic images. Often dressed all in white, with bow ties and beanie caps, these popular cheering sections fared best at schools out West (such as at the University of Southern California) where warm, sunny weather gave the flash-card sections a greater chance to perform.

And while articles and books predominantly featured male cheerleaders, *Just Yells* mentioned a coed squad in passing: "Two girls and a boy—a triangle in white—made an effective rooter group for one game. I have no doubt that this was one element in winning a well-fought contest."

Finally, women entered the cheerleading scene. On pep squads, with gymnastic and tumbling routines, and as song girls, women added an attractive new dimension to sideline diversions. By the mid-1920s coed squads proliferated across the country. In 1924 Dr. Wiltse, the Ohio State coach, was quoted in *The Literary Digest:* "We have had a great run of girl cheer-leaders in high schools in this state. . . . In the case of most of these girls, they are fine-looking, bobbed-haired, rhythmic, well-formed individuals who are just outstanding girls. They seem to have a better sense of rhythm than most boys, and get splendid results by occasional intensity of action."

The 1930s

In the 1930s pom girls, otherwise known as song girls, hit the field. With choreographed dance routines and pom-pons for props, these forerunners of modern dance/drill teams were pure entertainment. The same could be said for marching bands, majorettes, flag corps, and mascots—full of fun and pranks. Football fields were awash with all kinds of eye-catching hoopla.

And that excitement and energy wasn't confined just to the field. Cheerleading spirit hit the press, and soon the advertising world showcased cheerleaders in a multitude of ads having nothing to do with football. Women featured prominently, in ever-shortening skirts, with a gleam in their eye and a product in their hand.

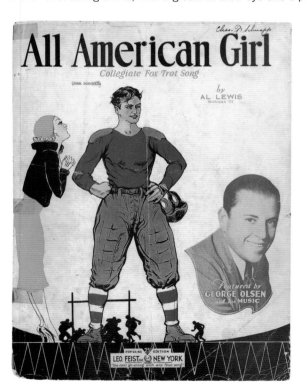

"She's got a half-back at Pennsylvania,
She's got a quarterback at Yale as well.
She corresponds with an end at Centre,
and a center at Cornell.
She wears a pin of a guard at Harvard,
a Stanford tackle has her in a whirl,
She's got a sweet-heart at ev'ry college,
She's just an All American Girl!"

—Song by Al Lewis

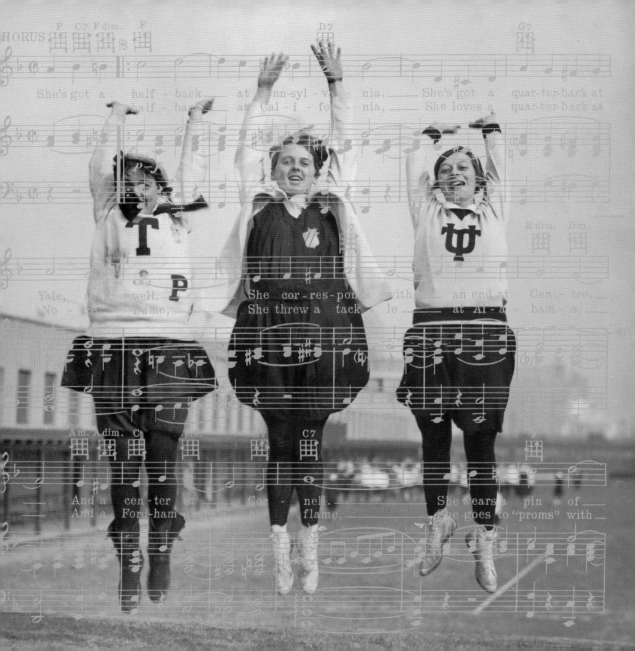

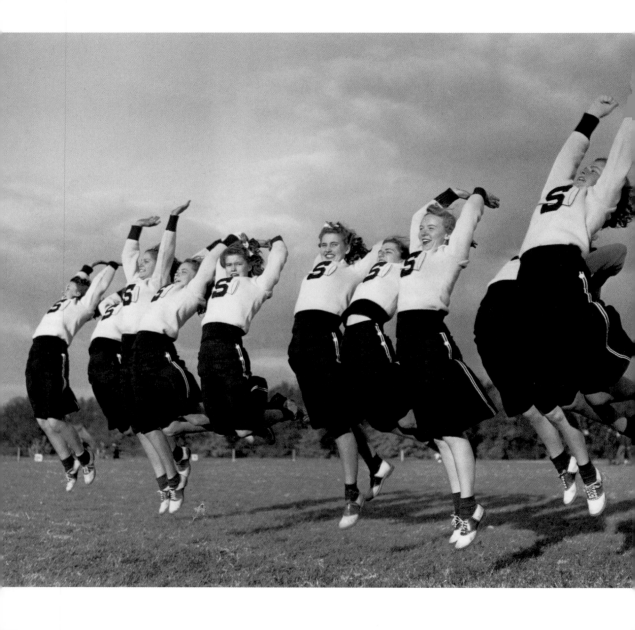

The 1940s

By the 1940s, girls made up the bulk of the squads. Swingy skirts and crepe-paper poms were all the rage. As World War II took men out of the mix, women stepped in to shine solo in the spotlight. And shine they did. Routines became more elaborate and choreography more complicated. Then the nature of cheerleading changed again. In 1948 the first cheerleading camp was held. Lawrence Herkimer (known in cheering circles as Herkie), a former cheerleader at Southern Methodist University, hosted the camp's cheer section. It was a runaway hit, and Herkie discovered his calling, creating the National Cheerleading Association (NCA) in 1949—the first organization of its kind.

The 1950s

Through camps and clinics, cheerleading reached new heights of precision and execution. Workshops took place on weekends and during the summer, providing ideal opportunities for cheerleading squads to train with professionals. In 1953 Herkimer founded the Cheerleader Supply Company, a catalog company that sold uniforms, pom-pons, and cheerleader supplies to groups across the country. His pom-pon kits were a staple, and so were the pleated cheerleader skirts that his wife, Dorothy, invented. In 1957 he introduced the spirit stick, that all-important symbol of a cheerleading squad's unmatched spirit—still one of the most coveted prizes at cheerleading camps today.

The 1960s

The 1960s witnessed a pom-pon revolution. Fred Gastoff invented poms made of vinyl instead of paper, and the days of cheerleaders standing in the rain with dye running down their hands were over. The International Cheerleading Foundation, the innovator in cheerleading competitions, along with the UCLA cheerleaders,

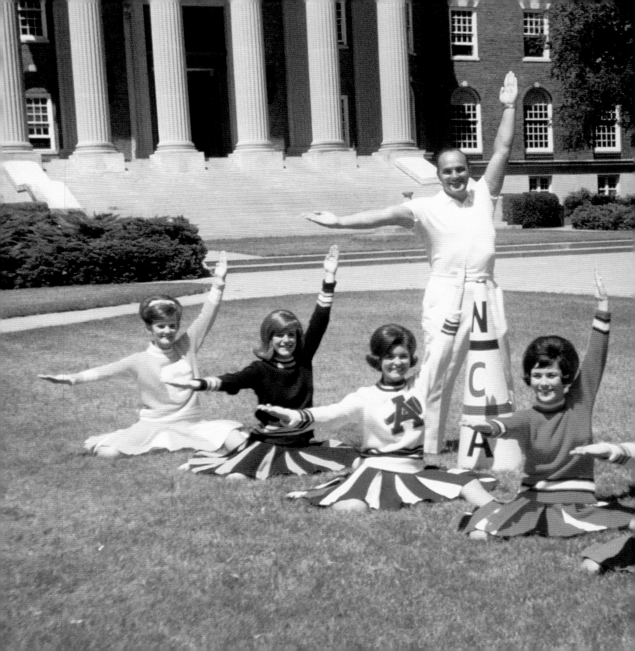

RAH FOR FETCHING FASHIONS!

RAH FOR EXCITING FICTION AND COMICS!

RAH FOR SMOOTH DATE TIPS!

RAH FOR MUSIC, MOVIES, CAREERS, PEOPLE!

RAH FOR MISS AMERICA, CREATED TO HELP EVERY TEEN-AGER!

introduced vinyl poms to the cheering world, and a bouncy new style of pom-pon routine was born.

In 1967 the International Cheerleading Foundation also established the "Cheerleader All-America Awards," recognizing and celebrating cheerleaders who stood out from the rest.

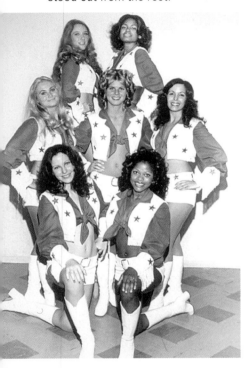

The late 1960s saw another groundbreaking change in cheerleading—the very first professional cheerleading squad. The Baltimore Colts, a professional football team, broke from the tradition of having local high school squads perform at halftime. Instead, they hired their very own squad of professional cheerleaders to add glitz and glam to game day.

The 1970s

Then came the Dallas Cowboys Cheerleaders. Until the early 1970s the Dallas Cowboys had a cheering squad—the CowBelles & Beaux—a group of local high school cheerleaders. But Tex Schramm, the Cowboys general manager, wanted more. His staff put together a dance troupe of talented, beautiful women to perform Broadway-style dance routines at halftime. Their outfits—short white shorts, go-go boots, and midriff-baring tops—soon became some of the most recognizable uniforms on the planet. Stars of an entirely new genre were born.

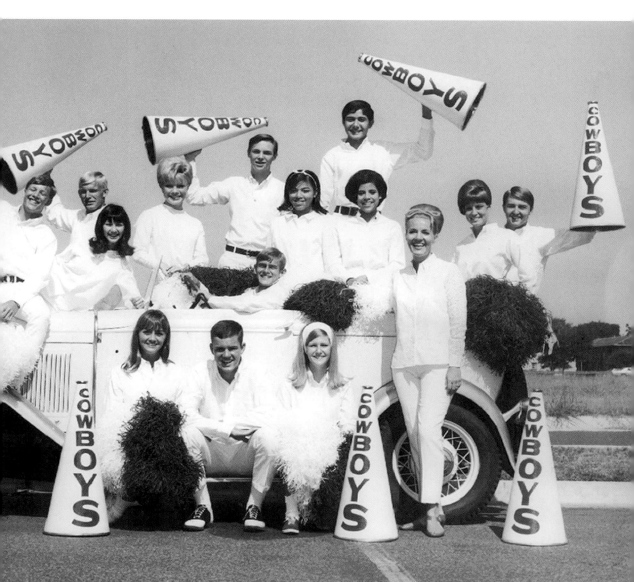

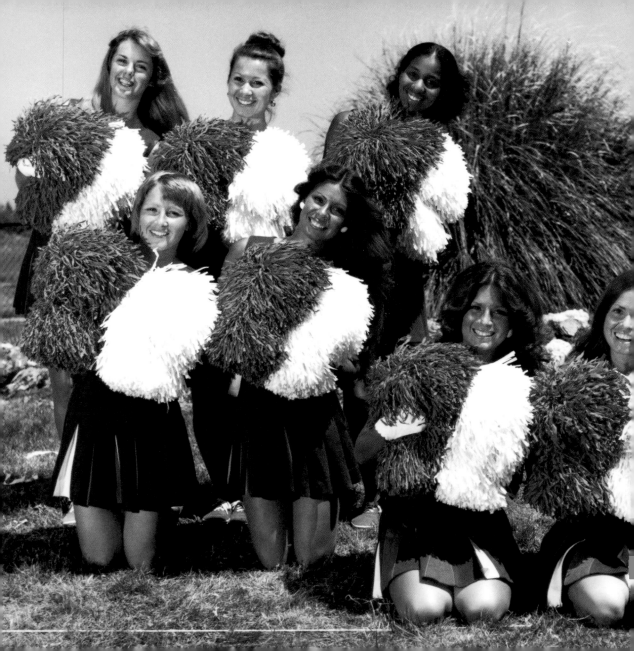

In 1972 Title IX was passed, forever changing the sports opportunities available to girls. Cheerleading often had been the only avenue open to sports-minded girls. Now this landmark legislation, which banned sexual discrimination in school academics and athletics, opened up countless options. And while many would-be cheerleaders pursued other sports, cheerleading continued to flourish, as squads soon performed double duty, cheering at women's events as well as at men's.

Another hallmark of the 1970s was the explosion of cheerleading competitions. As various cheer organizations sponsored camps and invitational competitions, the stakes at the high school and college levels rose. Cheerleading became a sport unto itself. Coed squads were once again all the rage, as stunts and routines grew increasingly complicated. In 1978 the Collegiate Cheerleading Championships aired for the first time, and cheerleading found a new home, not to mention new fans, on TV.

The 1980s

All-Star Teams appeared on the horizon in the 1980s, and cheerleading staked yet another claim as an independent sport. All-Star teams don't represent schools or cheer at games. They don't support other sports or perform at pep rallies. They practice. They compete. They cheer—just for the love of cheering. All-Star competitions have sprung up worldwide, sponsored by major cheerleading organizations. Just like high school and college teams, All-Star teams travel the globe to compete against cheerleading elite. The reward? The honor and glory of being recognized as the best.

The 1990s to Today

Through the 1980s, 1990s, and into the twenty-first century, cheerleading has continued to gain in popularity. Camps, clinics, competitions, and All-Star teams have opened up the exhilarating experience to millions of enthusiasts around the world.

Cheerleaders are EVERYWHERE

They're on the high school squad, cheering at a basketball game, pom-pons waving overhead. Or they're on the college team, exhibiting tremendous gymnastic ability and competing around the country. They are glamorous professional dancers, performing elaborate halftime shows. And today, they are on the All-Star teams who cheer just for the love of cheering.

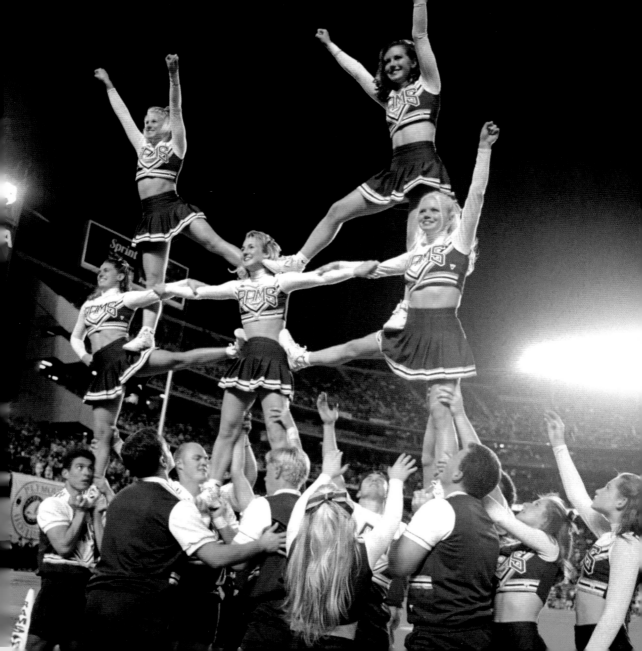

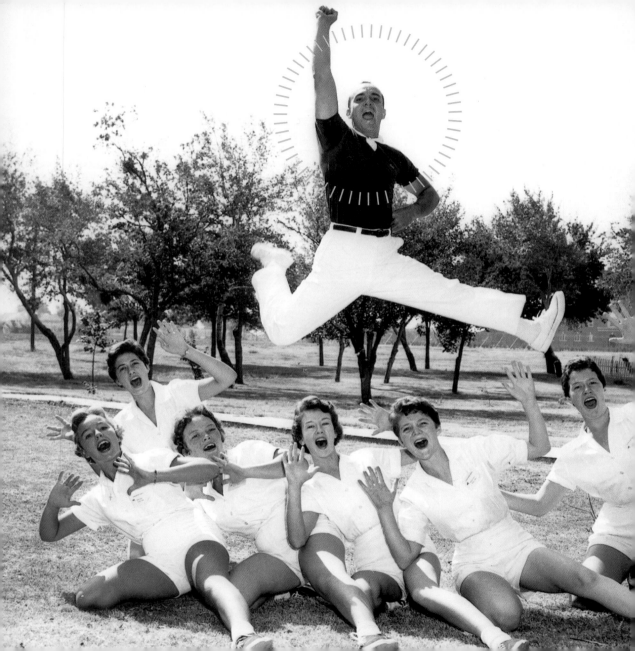

HERKIE

Lawrence Herkimer—known as the father of modern cheerleading, Mr. Cheerleader, and Herkie to the world at large—is a true innovator in the cheerleading world. He founded cheerleading camps, invented the spirit stick, and patented the pom-pon. He was a cheerleader himself, first at North Dallas High School and then at Southern Methodist University. His gymnastics training and outgoing personality were the secrets to his success. During his high school days, he even invented a new jump, still known as the "Herkie." It came about as he strove to throw himself higher into the air than ever before, his right fist pumping up to the sky, his right leg straight out in front, and his left leg hooked behind him, left arm by his side. This deceptively simple-looking move is still a mainstay in a cheerleader's repertoire.

In 1949 Herkie led a summer cheerleading camp, and fifty-two girls signed up. Using gymnastics and choreographed movements, he taught the girls how to motivate a crowd. This was something totally new. Never before had a camp focused on the finer points of cheerleading. Three hundred signed up the next summer, and Herkie was off and running. He founded the National Cheerleading Association in 1952 and soon started running week-long summer camps across the country. For $25 a week (which included training plus room and board), he provided cheerleading squads the opportunity to bond, to train with cheerleading professionals, and to learn to work as a group. During the school year he also ran day-long clinics, and kids showed up by the thousands. They'd train in the morning and then run onto the football field at halftime to lead a rousing cheer for the fans in the stands.

Herkie's definition of a cheerleader is just how one of his many fans describes him—energetic, enthusiastic, fit, full of desire, and perennially outgoing. As Herkie says, *"You can't lead without being outgoing yourself."*

THAT'S SHAKEROO TO YOU

It all started with an inventive high school cheerleader grabbing some colored crepe paper to wave while cheering on the football team. The idea caught on, and in the 1930s and 1940s precision squads performed choreographed routines with balls of paper streamers, often referred to as shakeroos. And then, in the 1950s, Lawrence Herkimer had a brainstorm while watching majorettes twirling their silver batons: if he added colored paper to the end of a stick, it would photograph much better than the batons. So he and his wife got to work making pom-pon kits in their garage. The kits included crepe paper, a stick, a wire to hold it all together, and instructions on how to assemble the poms and how to maintain their fluffiness, which could be done by taking a few strands of crepe paper at a time and scrunching them up toward the pom stick. He worked with innovators in the field to create fade-proof paper, flame-resistant paper, and an automated machine that would shred the paper just so. Herkimer patented his pom-pon and holds the copyright to this day. Then in the 1960s Fred Gastoff invented vinyl poms, leaving paper ones by the wayside. Today there are more poms on the market than one could ever imagine. Rooter poms. Classic poms. Multicolored poms. Bull's-eye poms. Target poms. Standard handle poms. Block handle poms. Show baton poms. Finger poms that attach around your middle finger with an elastic loop. Even cheer balls that are all pom and no handle at all. Yes, a perfect pom for every situation.

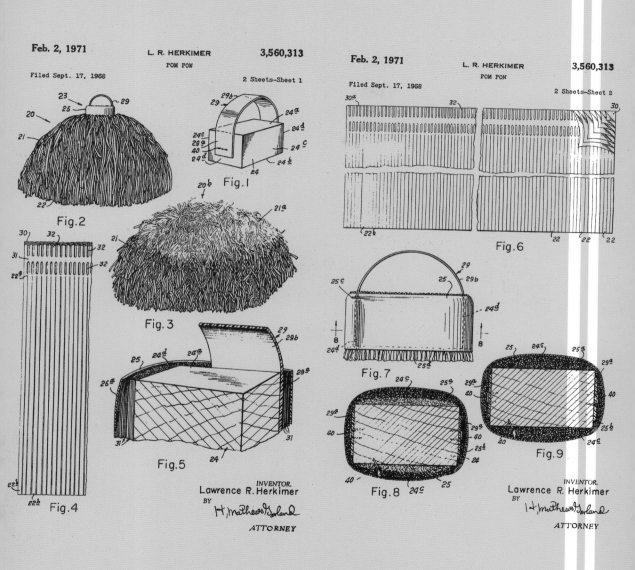

Fig.1

Fig.2

Fig.3

Fig.4

Fig.5

INVENTOR.

Lawrence R. Herkimer

BY

H. Matthews Garland

ATTORNEY

Fig.6

Fig.7

Fig.8

Fig.9

INVENTOR.

Lawrence R. Herkimer

BY

H. Matthews Garland

ATTORNEY

THE SPIRIT STICK, LITERALLY

Back in 1957, at a cheerleading camp, Lawrence Herkimer watched a squad perform with incredible enthusiasm, dedication, and spirit. The girls weren't the best performers, they didn't do the hardest stunts, and they didn't win the competition, but they were so outstanding he felt they deserved individual recognition. So he broke a branch off a tree and handed it to them, dubbing it the "spirit stick." The squad was thrilled and a new status symbol in cheerleading had come about. Today, the traditional spirit sticks are red-white-and-blue-striped batons and are given each evening at cheerleading camp to the group who showed the most spirit that day. The spirit stick is returned at the next day's end and awarded to a new group. Finally, one group wins the spirit stick at camp's end, and they bring it home, to place it with honor among their school's trophies and awards.

Photo courtesy Santa Ana Daily Register

G. 2

Pretty Marilyn Kellogg of Santa Ana (California) Junior College leaps high in an energetic "Tiger."

TALE OF THE TIGER

You've probably noticed that cheers are usually finished with a flourish, cheerleaders leaping into the air for an exclamation point of energy and exuberance. Many folks call that rousing jump a tiger. But where did that term come from? Some say it is derived from that renowned Princeton yell, which mentions its mascot, a tiger. But since that cheer originated in the 1870s or so, that's unlikely. In addition, the use of *tiger* is noted earlier (*A Dictionary of American English*, 1938, quotes *Knickerbocker Magazine* of 1856 mentioning the "giving of terrific cheers and a tiger"), so that theory is routinely dismissed. Others believe that the term *tiger* has its roots in the bizarre campaign gimmick of Mississippi politician S. S. Prentiss. While campaigning in 1842, Prentiss made speeches from the top of a tiger's cage. Whenever the audience cheered, he poked the poor tiger. The tiger, of course, let out a howl in response. So, perhaps the "tiger" came from American politics, of all unlikely places.

THE DALLAS COWBOYS CHEERLEADERS

For years professional teams borrowed cheerleaders from local high schools for halftime entertainment. But the fans just weren't interested in group cheers or response calls. Clearly they were looking for something else—something special. Enter Tex Schramm, the Dallas Cowboys general manager. In 1972, after seasons of relying on the local high school squad, the CowBelles & Beaux, Tex decided to shake things up. Believing entertainment to be an essential ingredient in the popularity of sports on TV, he, along with Dee Brock, who managed the CowBelles & Beaux, and Texie Waterman, a Dallas dance studio owner and dancer in her own right, created a glamorous, sophisticated dance troupe to perform at games. They chose seven talented and beautiful women, dressed them in hot pants, go-go boots, and midriff-baring shirts, and the Dallas Cowboys Cheerleaders were born.

The fans were thrilled. It took just one glance, in January 1976, at Super Bowl X, for the rest of the world to catch on. A TV cameraman, during a break in the action, caught the Dallas Cowboys Cheerleaders on the sidelines—their sparkling blue-and-white outfits look great on camera. One of the cheerleaders winked at the cameraman, while 75 million viewers watched.

The Dallas Cowboys Cheerleaders experienced popularity and fame unequaled by any other professional cheerleading squad. Known as "America's Sweethearts," they've made countless TV appearances and have even starred in two made-for-TV movies. They've appeared on posters, calendars, and in commercials. They've traveled the globe, performing for U.S. troops and fans the world over. Their talent, along with their hand-created, trademarked uniforms, catapulted them to icon status. The Dallas Cowboys Cheerleaders have changed the look of professional football games forever.

cheerleader

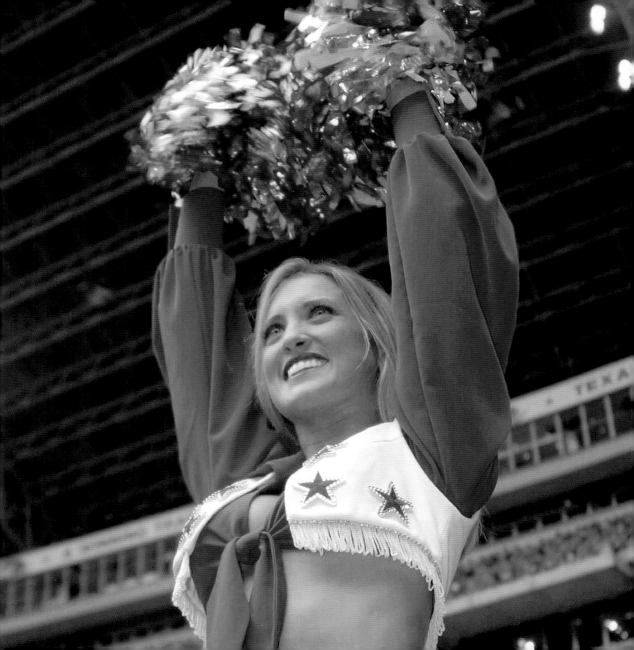

Cheerleading
Fashion

AH, THE UNIFORM! That's half the reason to join the squad, isn't it? While we think of uniforms as fairly standard—a sweater, a pleated skirt, and pom-pons—that wasn't always the case. Throughout the years, uniforms have changed radically. Skirt lengths have dipped to the ankle and risen to the thighs, and saddle shoes have morphed into specially designed athletic footwear. These extreme changes reflect the ever-shifting styles and mores of our times. All you need to do is look at the long and swingy skirts of the early 1920s or the go-go boots on cheerleaders of the 1960s to get a sense of what was going on in the world at the time.

The earliest cheerleaders—we're talking boys here—generally wore pressed slacks and matching sweaters—a version of their casual street clothes. With a little contrasting piping, and a school emblem on their chest, they were good to go. Simple and understated, their matching outfits gave them a unified look on the field. And take note: boys' outfits look remarkably similar today.

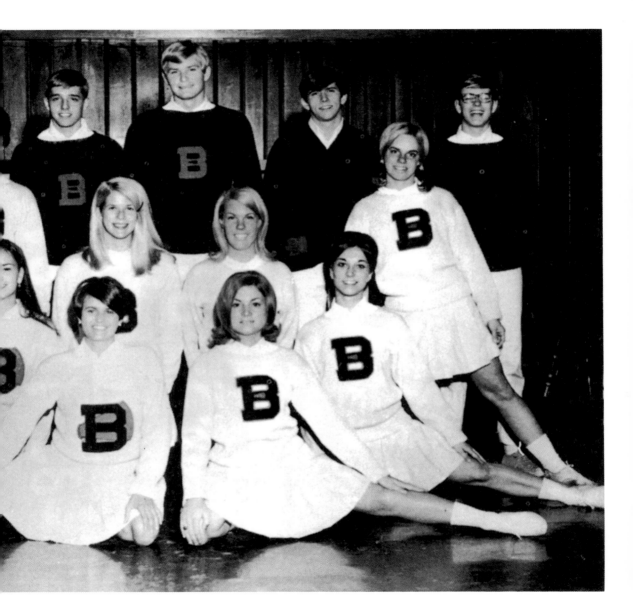

Girls, however, had far more leeway in their uniform styles. When they first hit the field back in the early 1920s, they wore long skirts that often reached all the way to the ankle. These long skirts

kept their legs warm during cold November afternoons and also created a sense of modesty. There was no way fans could get much of an eyeful with all that coverage. But it was just a few short years later that flappers caused a fashion riot with their knee-skimming dresses.

As the years passed, skirt lengths steadily rose, and the girls showed a little more skin, but cheerleaders kept firmly within the boundaries of taste and decorum. A cheer manual from the 1940s stated the guidelines quite clearly:

1. *The most important consideration is neatness.*
2. *Allow for freedom of motion, but avoid ill-fitting, loose-hanging sweaters, jackets, or other garments.*
3. *Do not wear colored undergarments which show through or clash with colors in your outfit.*
4. *Do not wear any apparel which may cause bulges.*
5. *Stay well within the bounds of good taste and modesty.*

P. & A. photographs

In action High School
average sense of rhyt
yell fo

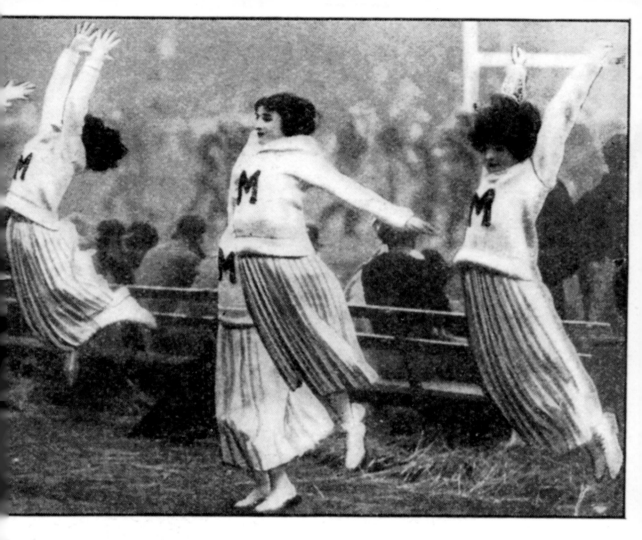

"AKE IT SNAPPY NOW, FELLERS"

netimes put no mean kick into cheer-leading because of their better
is aviating sextet have just reached the crescendo of a complicated
s High's" football team in a climax at the goal posts.

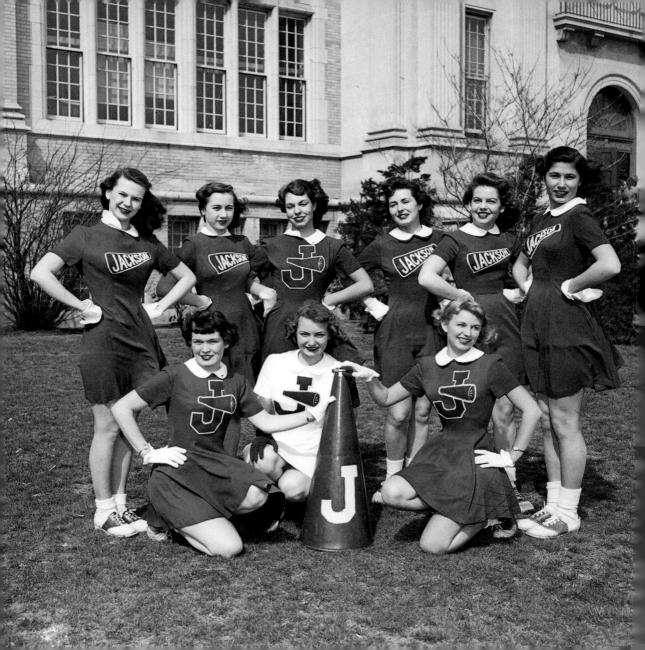

It was all about looking CLEAN-CUT, NEAT, and COORDINATED.

Cheerleaders represented their schools and outrageous, over-the-top statements were just not permitted—until, of course, the 1960s, but more on that later.

In the 1930s and 1940s cheerleaders' uniforms closely resembled everyday school clothes. Outfitted in matching skirts and sweaters, jumpers and blouses, or culottes and jackets, cheerleaders customized contemporary fashion for game day. Handy girls could sew a megaphone-shaped patch on the front of a sweater and be game-ready. Handfuls of colored crepe paper and megaphones in school colors finished off their outfits. Sporting a pair of bobby socks and saddle shoes, they were ready for the sidelines.

After World War II, with no more rationing of fabric, skirts grew long and swingy once again, mirroring poodle skirts, which were immensely popular at the time. Using their home-economics skills, girls continued to make their own uniforms until the birth of Cheerleader Supply Company—a catalog that Lawrence Herkimer created expressly for cheerleaders. So whether the squad hailed from a big city or a rural community, the girls had equal opportunity to make a fashion statement that was coordinated and polished. Herkie provided everything a cheerleader needed to pull off a perfect, peppy look. She could simply start with her school colors and then pick and choose from all the accoutrements in the catalog pages—uniforms, poms, megaphones, emblems, and skirts—all matching, all meant to complement one another.

Around this time, Dorothy Herkimer invented those crisp, fresh skirts with pleats-that-never-quit—staples of cheerleading fashion. They had eight pleats. Sixteen pleats. Contrasting colors inside the panels. And they were short, shorter,

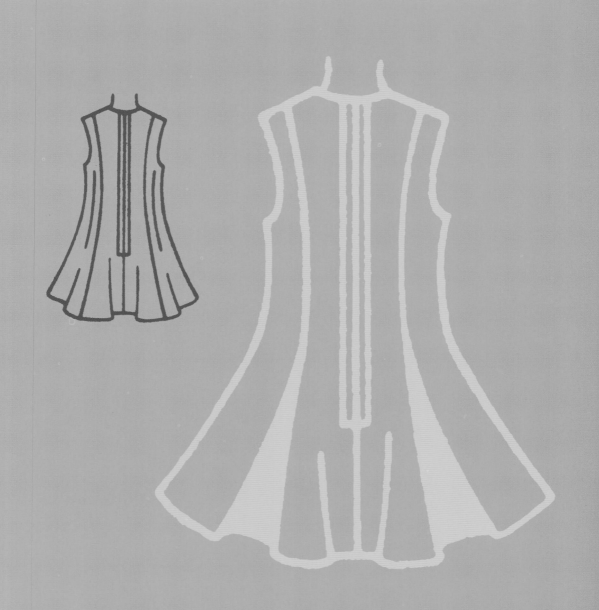

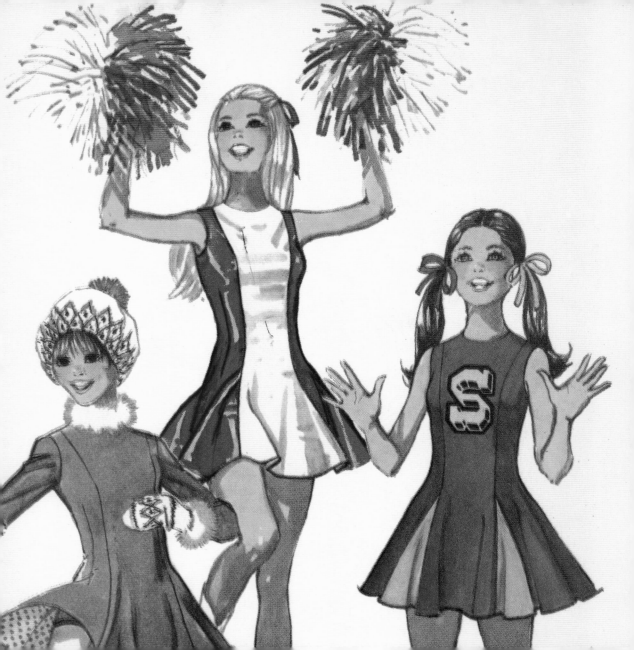

shortest. When cheerleaders spun and twirled, the stiffly pressed skirts flared straight out, with alternating colors flashing. Jumps and stunts had never looked better.

The 1960s brought radical change to cheerleading fashion. First, the miniskirt became de rigueur not just for counterculture types but for folks of every stripe. Skirt hems rose to the upper thigh. Some squads even sported hot pants and go-go boots. Now, those were the days! Though girls sported long straight hair or out-of-this-world Afros, in the cheerleading world, neatness and conformity still counted. Cheer-leading manuals of the day recommended that a squad's hairstyles match and that cheerleaders resist the temptation to wear too much makeup. So even though cheerleaders of the 1960s and 1970s showed a lot of skin and a lot of personal-ity, it was still all about a complete look, a team effort, and a coordinated squad.

As cheerleading developed into a sport in its own right, with more challenging stunts and difficult maneuvers, its uniforms grew even smaller. Halter tops, sleeveless shells, and fitted sweaters took the place of blousy tops and loose-fitting letter sweaters. From a perfor-mance standpoint, this made sense—who can

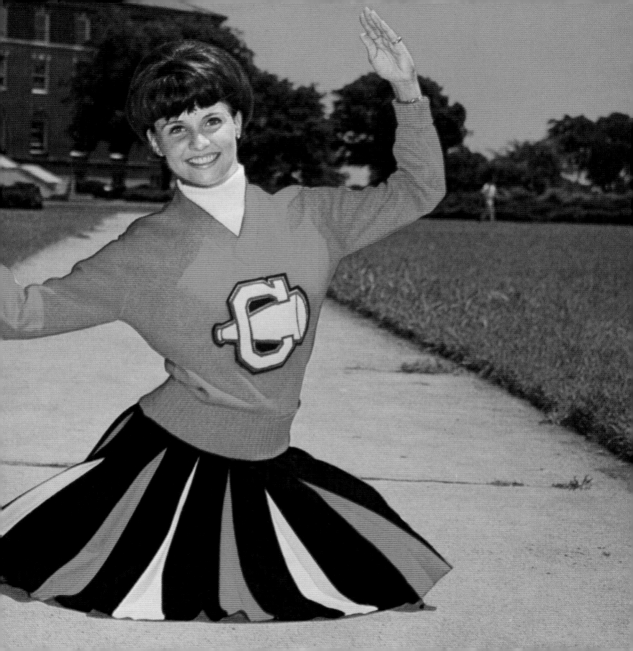

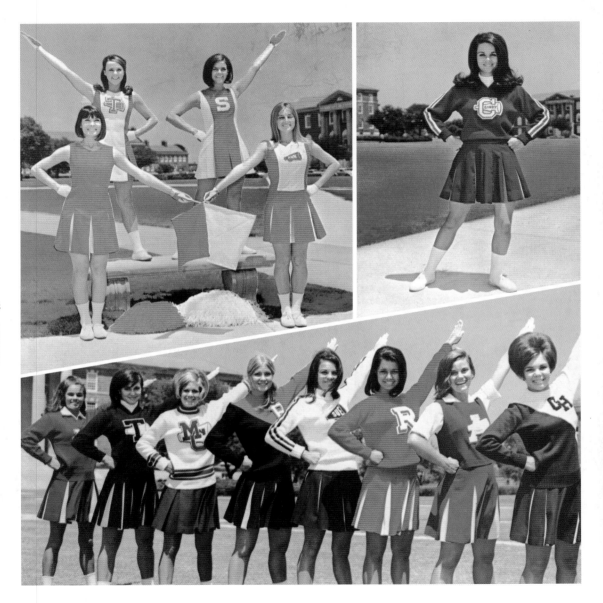

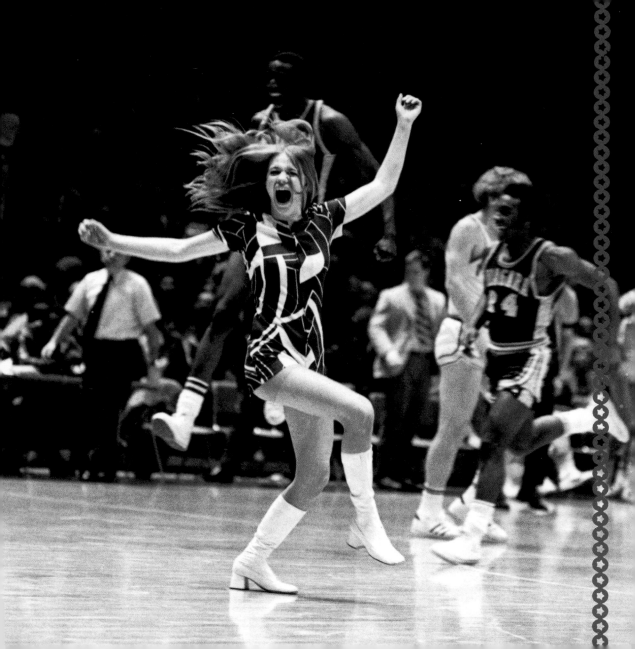

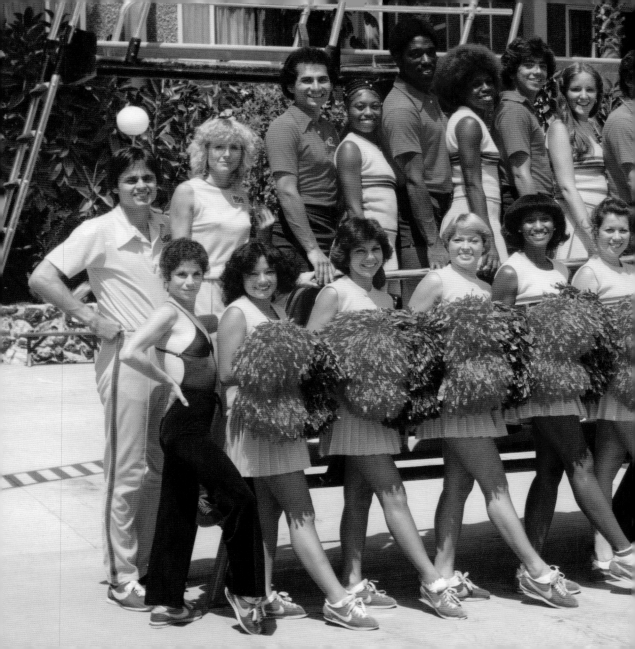

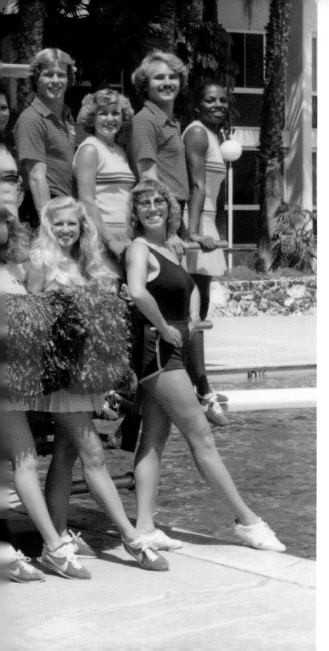

afford to be weighted down in a wool skirt and bulky sweater when being catapulted to the top of a pyramid? Specially designed athletic shoes replaced saddle shoes and loafers. Vinyl poms, in an ever-growing variety of styles, sizes, and colors, replaced paper poms.

Today cheerleading fashion is a huge industry unto itself, extending far beyond uniforms and poms. There is almost nothing in the fashion world that doesn't exist with a cheerleader spin—warm-ups, carry bags, hair accessories, sleepwear, and lounge wear. And the seemingly endless variety of uniform choices guarantees that each squad can look unique. While we may miss the days of saddle shoes or go-go boots, one thing is for sure—that pleated skirt and those pom-pons will always be in style.

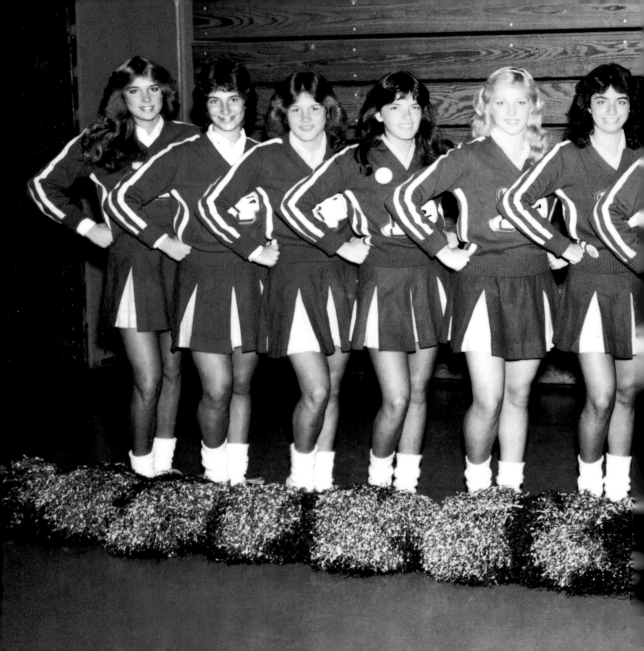

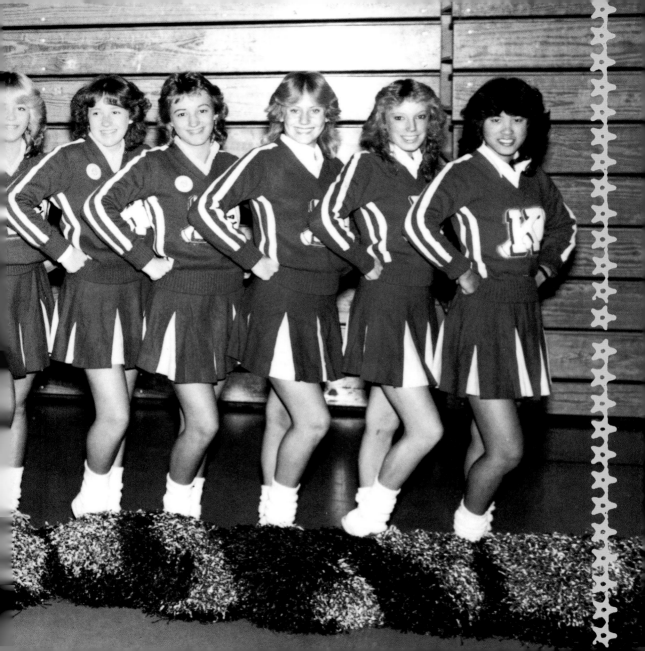

pom

pon

TO POM OR NOT TO POM

Pom-pons. We all know them when we see them. We know what they're used for. We know who shakes them and what they're called . . . or do we? Is it pom-pom or pom-pon?

 While dictionaries would have you believe they're called pom-poms, the official industry name for those fluffy, colored balls of streamers attached to a handle is technically pom-pon. Derived from the French word *pompe*, a decorative feathery or woolly tuft adorning hats or slippers, *pom-pon* is the term used by people in the know. You may be tempted to call them pom-poms, but don't. It's a terrible cheerleader faux pas! However, if you absolutely can't keep the name straight, just call them poms, and you'll be fine.

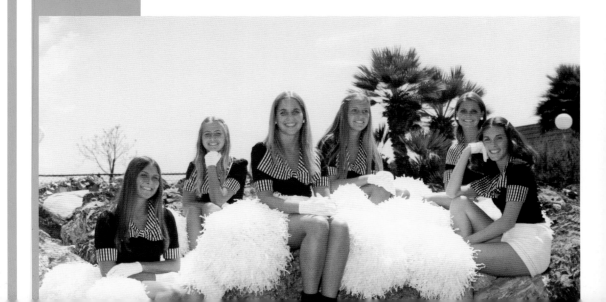

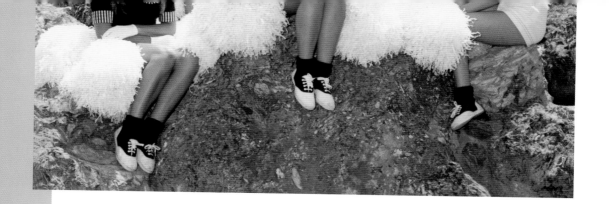

COOL SHOES

What is it about saddle shoes and cheerleaders? Those two-toned, lace-up, rounded-toe, oxford-style shoes certainly aren't the prettiest footwear—at least to the contemporary eye. But back in the day they were the be-all and end-all in footwear—not just for cheerleaders. It took a while for them to catch on, but once they did, saddle shoes swept the nation.

First introduced to the sporting community by Spalding in 1906, saddle shoes featured an alternate colored band that reinforced the shoe and provided extra support. But nothing else about them appealed to athletes. Eventually golfers warmed up to the saddle shoe—perhaps they liked the way the two colors coordinated with their plaid pants. Saddle shoes seemed destined solely for the fairway, until surprisingly they became a mainstay in teenagers' closets in the 1940s. With rolled-up jeans, white button-down shirts, and saddle shoes, teenage girls got to horrify their parents while making a collective fashion statement. They were the epitome of cool, so of course cheerleaders adopted them as their own. Saddle shoes became a status symbol, as noted in *The Cheerleader*, by Ruth Doan MacDougall, a coming-of-age novel chronicling high school cheerleaders in the 1950s: "She was still wearing her saddle shoes, the only part of the uniform they were allowed to wear home. Green saddles showed beneath the slacks of all the cheerleaders, badges of honor."

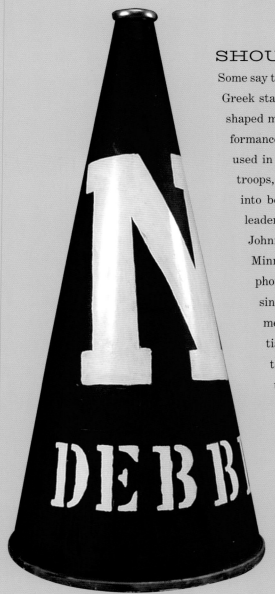

SHOUT IT OUT!

Some say the modern megaphone originated from ancient Greek stage masks. These masks, carved with funnel-shaped mouths, amplified actors' words during a performance. Others believe cone-shaped animal horns, used in ancient battles to shout instructions to the troops, were the inspiration. However they came into being, they've been indispensable to cheerleaders from the start. First taken in hand by Johnny Campbell in 1898, at the University of Minnesota, cheerleaders have yelled into megaphones at countless games and rallies ever since. Many cheerleaders personalize their megaphones with the school's name, initials, or mascot emblazoned on the side, often with the cheerleader's name stenciled underneath in the team's colors. Regardless of their size, construction, or decoration, megaphones are the perfect tools to send cheerleaders' yells to the furthermost seats in the stadium, letting every fan hear them loud and clear.

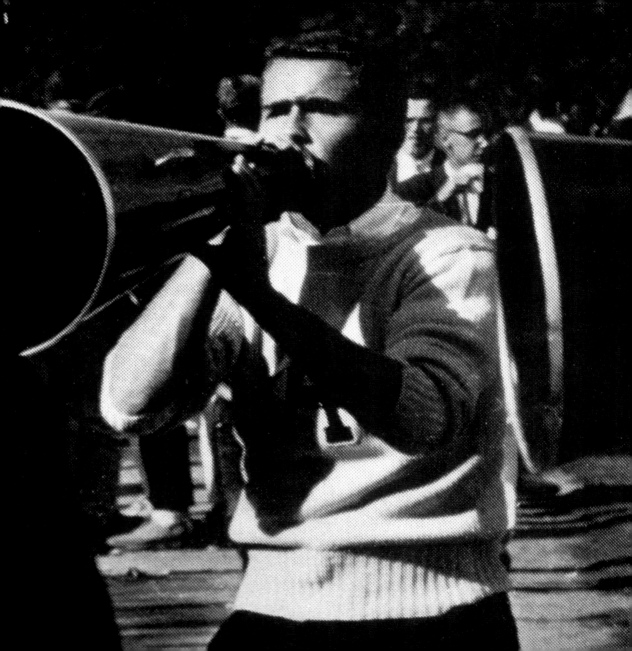

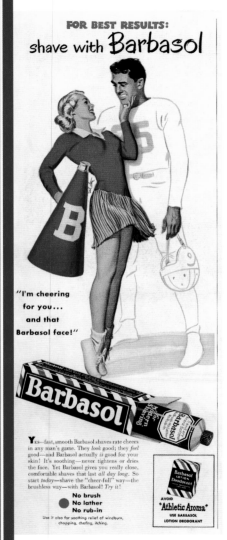

THOSE EYES, THAT SMILE . . . THAT SKIRT!

In the mid–twentieth century, advertisers couldn't help
but embrace the wholesome allure of cheerleaders.
What with their clean-cut and enthusiastic image, their
presence gave a seal of approval to everything, from
car stereos to soda pop. Ads for items as disparate as
watches, sausages, ink blotters, tampons, and even
cigarettes looked to win consumers with a cheerleader's
friendly, sparkling smile. With eyes twinkling and short
skirts blowing in the breeze, that familiar icon evoked
health, vitality, well-being, and youth. She was sexy but
innocent, and she appealed to women, men, and teenagers
alike. What consumer could possibly resist her efferves-
cent energy?

First in the field

Baby Ruth is the best "forward pass" in the game; it scores every time—and all the time!

And it has the largest, most enthusiastic following of any candy in America.

Forty million people eat **Baby Ruth** with delight. Over five million bars are sold every day. Over $250,000 worth of nickels pass over the candy counters daily for this favorite confection.

Fits every taste—fit for any taste—Curtiss **Baby Ruth.**

CURTISS CANDY COMPANY

New York CHICAGO San Francisco

Boston Los Angeles

CURTISS
Baby Ruth
America's Favorite **5**c

5c

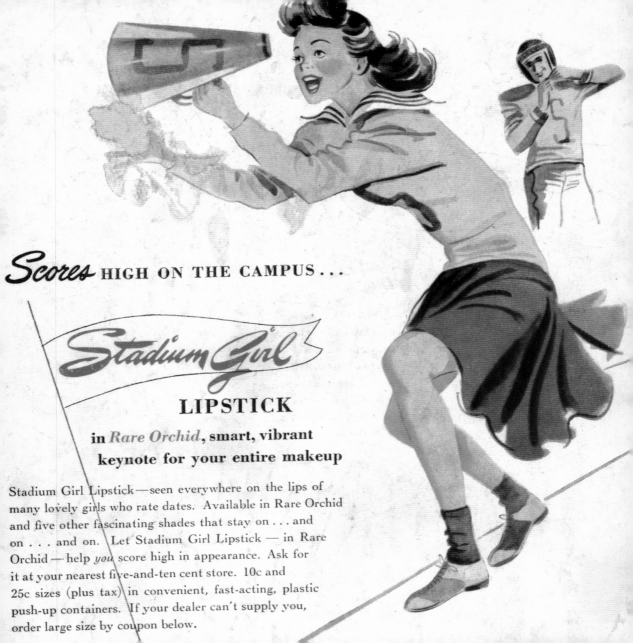

Scores HIGH ON THE CAMPUS...

Stadium Girl

LIPSTICK

**in *Rare Orchid*, smart, vibrant
keynote for your entire makeup**

Stadium Girl Lipstick—seen everywhere on the lips of
many lovely girls who rate dates. Available in Rare Orchid
and five other fascinating shades that stay on . . . and
on . . . and on. Let Stadium Girl Lipstick — in Rare
Orchid — help *you* score high in appearance. Ask for
it at your nearest five-and-ten cent store. 10c and
25c sizes (plus tax) in convenient, fast-acting, plastic
push-up containers. If your dealer can't supply you,
order large size by coupon below.

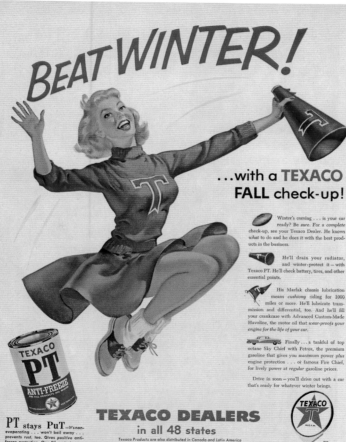

BEAT WINTER!

...with a TEXACO FALL check-up!

Winter's coming . . . is your car ready? Be *sure*. For a *complete* check-up, see your Texaco Dealer. He knows *what* to do and he does it with the best products in the business.

He'll drain your radiator, and winter-protect it — with Texaco PT. He'll check battery, tires, and other essential points.

His Marfak chassis lubrication means *cushiony* riding for 1000 miles or more. He'll lubricate transmission and differential, too. And he'll fill your crankcase with Advanced Custom-Made Havoline, the motor oil that *wear-proofs* your engine for the life of your car.

Finally . . . a tankful of top octane Sky Chief with Petrox, the premium gasoline that gives you maximum power *plus* engine protection . . . or famous Fire Chief, for lively power at *regular* gasoline prices.

Drive in soon — you'll drive out with a car that's ready for whatever winter brings.

TEXACO PT ANTI-FREEZE

PT stays PuT — it's non-evaporating . . . won't boil away . . . prevents rust, too. Gives positive anti-freeze protection. One fill protects your radiator all winter.

TEXACO DEALERS
in all 48 states

Texaco Products are also distributed in Canada and Latin America

THE TEXAS COMPANY

TUNE IN . . . TEXACO STAR THEATER starring JIMMY DURANTE on television, Saturday nights, NBC.

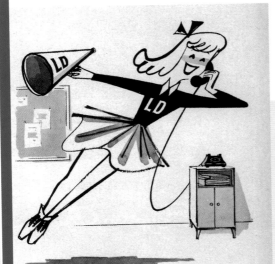

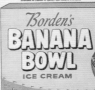

he sassy one from Canada Dry.

You'll want to go steady with Wink anytime your thirst tells you to drink.

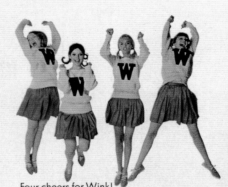

Four cheers for Wink! It's different from what you're used to.

Smooth but sassy, take a sip and you'll flip for Wink.

Wink GRAPEFRUIT BEVERAGE

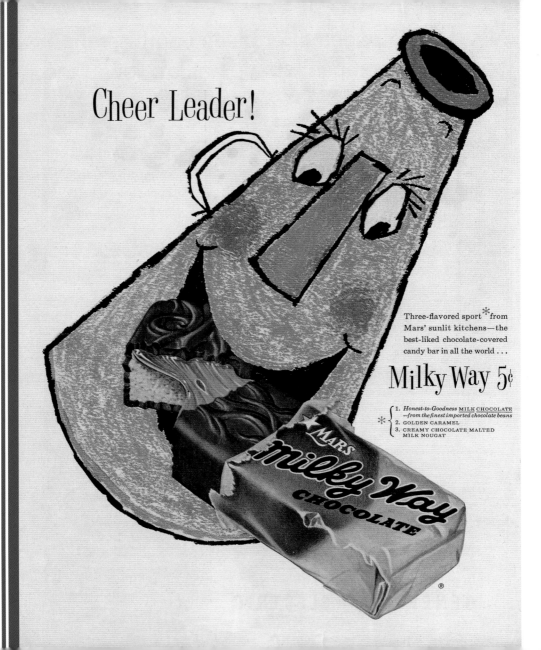

Cheer Leader!

Three-flavored sport*from Mars' sunlit kitchens—the best-liked chocolate-covered candy bar in all the world . . .

Milky Way 5¢

* { 1. *Honest-to-Goodness* MILK CHOCOLATE —*from the finest imported chocolate beans*
 2. GOLDEN CARAMEL
 3. CREAMY CHOCOLATE MALTED MILK NOUGAT

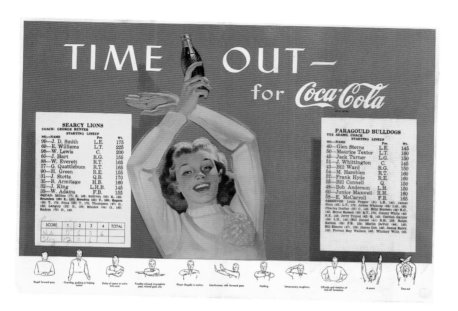

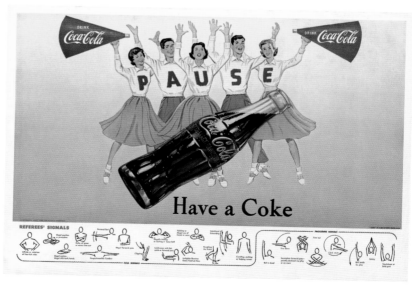

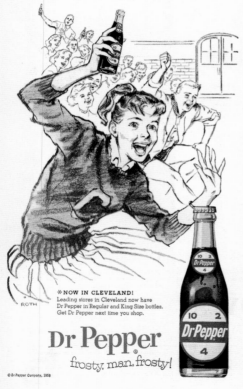

Scores high when you're dry...this

fresh, clean taste!

Have yourself a bottle of 7-Up—you'll really feel like cheering!

That special 7-Up taste alone wins big ovations. But there's more: while you're enjoying it, the dryness in your mouth and throat just fades away. No sticky taste or come-back thirst, either. You're ready to outshout 'em all again!

And say—when you're eating during the game, or afterwards, have a 7-Up. Goes great with everything from popcorn to pizza!

New from Walt Disney Studios **ZORRO** ®
Daring, dashing adventure Every week on ABC-TV
© 1957 Walt Disney Productions

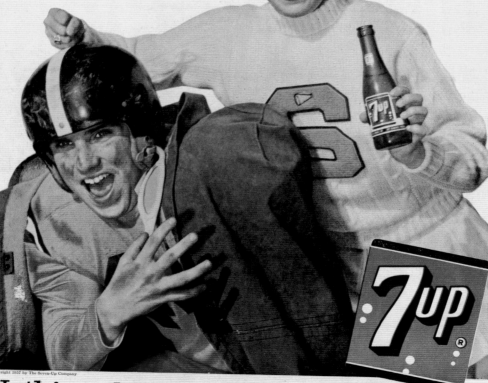

Nothing does it like Seven-Up!

hat
IT
TAKES

"*When you become a cheerleader, you become an 'instant.'* **I-N-S-T-A-N-T.** *No, not an instant cup of coffee, an instant success. You become instantly popular, instantly imitated, an instant trend-setter. What you do, what you wear, how you act, what you are—everything about you will be carefully studied by all the other girls.*" —Lawrence Herkimer, *Seventeen* magazine, 1973

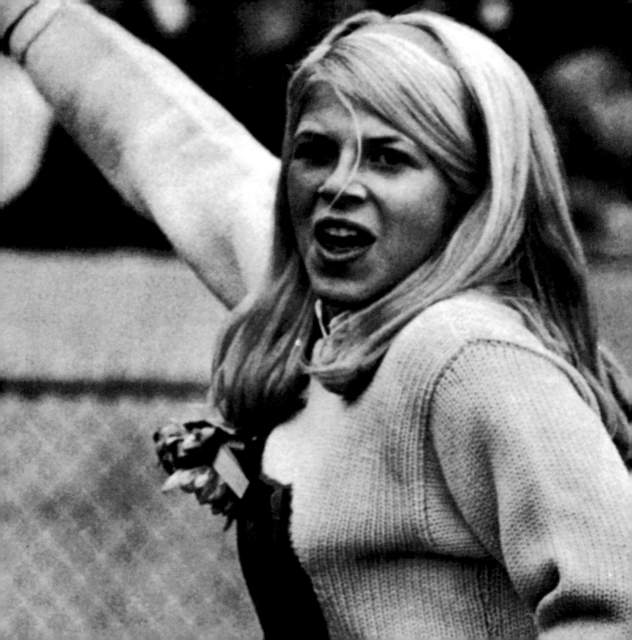

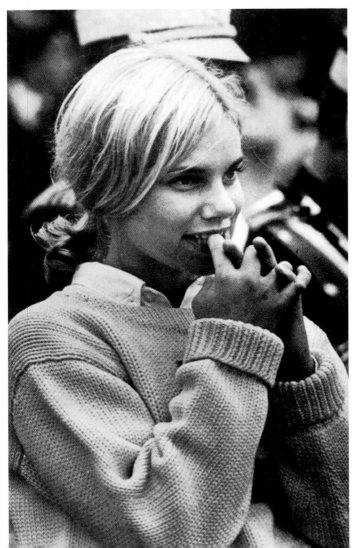

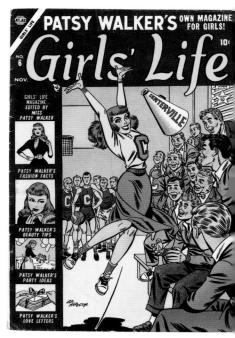

YOU JUST S

NOW, WE ALL KNOW THAT THERE'S MORE TO CHEERLEADING THAN GOOD LOOKS AND POPULARITY. But back in the heyday of cheerleading a perfect ponytail and a beefy football player on your arm meant easier access to the squad. That's not to say that hard work and dedication weren't involved—on the contrary. As soon as the notice for tryouts was tacked on the bulletin board or listed in the school newspaper girls got busy practicing their moves.

Everyone was all aflutter. *Who's trying out? How many spots are open? Were they JV? Varsity? Are the judges looking for perfect splits? Handsprings? Ponytails? Who'll make the squad?* Cram sessions were held in backyards after school. Shouting until the sun went down, cheerleader wanna-bes practiced until they went hoarse, their legs grew numb from jumping, and their arms became too leaden to lift even poms. Nothing could match the excitement, not to mention anxiety, of tryouts.

On the day itself, with hearts pounding, palms dripping, and nerves stretched to the limit, candidates plastered on a big smile and launched into the routine, the cheer, the stunts, the jumps: game-day pressure in a two-minute tryout. Some poor souls had to run up onto the stage, and, in front of the entire student body, perform all alone, often with a cheer they had made up themselves. Others, thankfully, got to cheer in groups of other hopefuls:

WE GOT THE STYLE WE GOT THE BEAT
GHT BACK AND WATCH US COMPETE!

The last jump was landed, the last words shouted, and then there was the agony of the wait. Then came the questioning *(Was the jump high enough? Did my voice carry? Was I on the beat?)* and the praying for divine intervention if necessary.

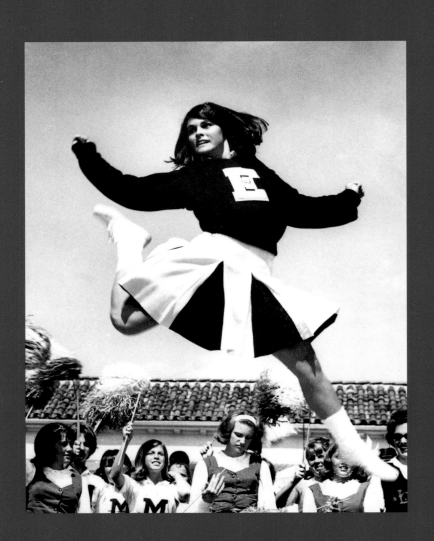

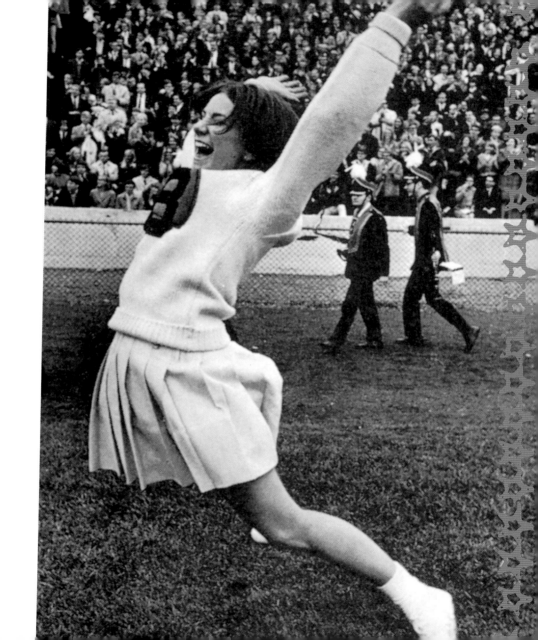

Looking for precision and personality, the judges watched with keen attention, taking in every step, every syllable, and every jump. Some judging panels were made up of faculty members, while some had current cheerleaders rounding out the vote. Some schools even allowed students to vote for the cheerleading squad, while others invited objective members of the community, such as civic leaders or dance instructors, to make the selection. It's horrifying to think that a local librarian, the math teacher, or that older girl from camp had the power to elevate some students to the pinnacle of cool, while at the same time dashing others' hopes and dreams.

Some judges immediately notified the girls who made it. Others made the girls wait, excruciatingly, until results were posted the next day. Everyone rushed to the bulletin board, hoping to see their name listed. And if a girl found her name, her life changed in that moment. Being a cheerleader meant being "it." While cheerleading today is more about sportsmanship, back in the 1940s and 1950s it was undeniably all about popularity. Cheerleaders often dated football and basketball players—the hunkiest boys at school. Everyone knew their names—they were the center of attention on game day, not to mention at pep rallies, fund-raisers, and school events. It's no wonder that a cheerleader was generally elected homecoming queen, not to mention prom queen and lady of her court. Younger girls dreamed of one day making the squad and experiencing firsthand the status that went along with the uniform. And those pom-pons and saddle shoes were definitely status symbols. Every hour spent sweating on the field during the summer, every practice session, every camp, every clinic, every rehearsal was worth the honor and glory of being a cheerleader.

When football season kicked off in the fall, routines had to be polished and perfected. Cheerleading coaches, generally gym teachers or other staff faculty, worked with squads to create an engaging and entertaining repertoire of cheers

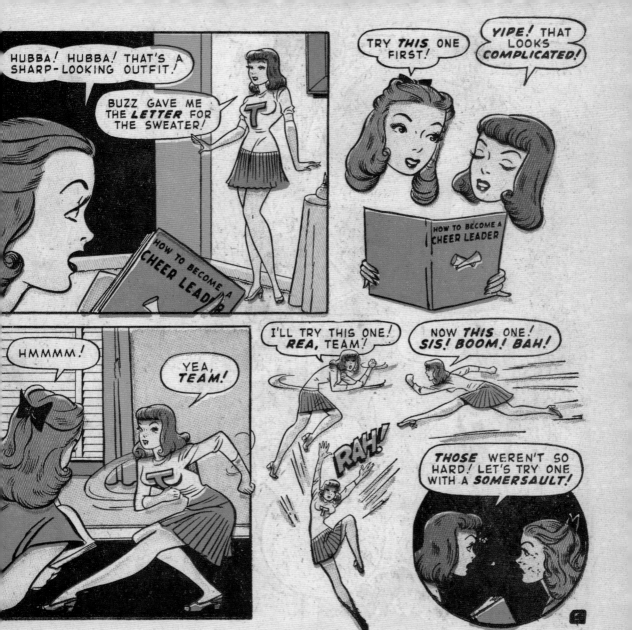

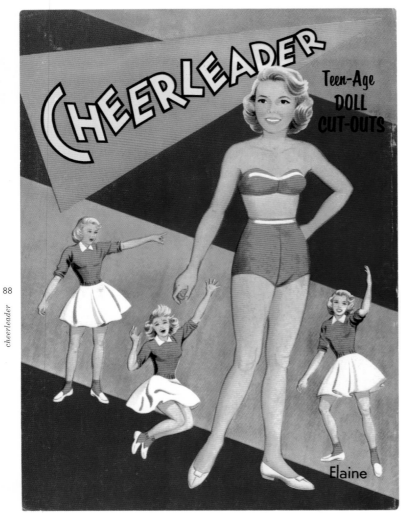

cheerleader

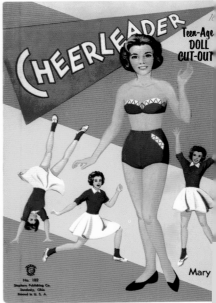

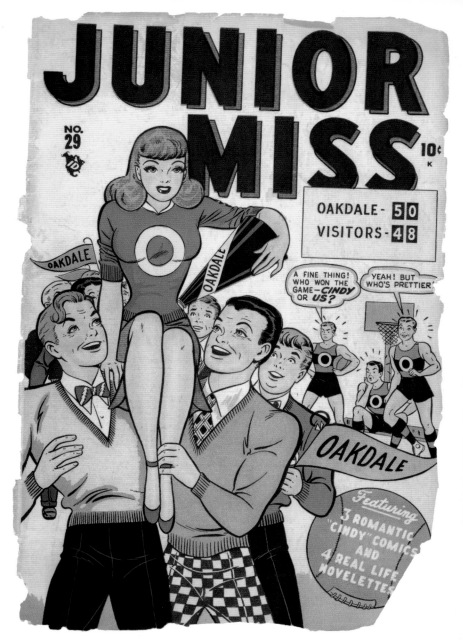

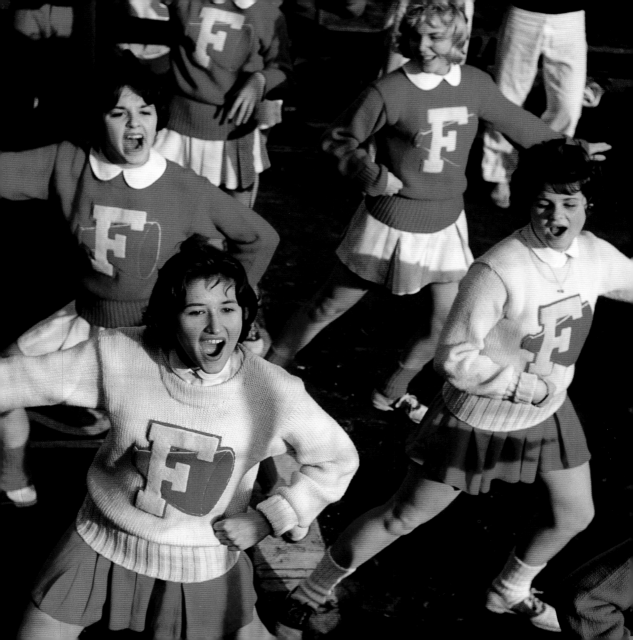

and stunts. And come fall, cheerleaders practiced, practiced, practiced, twice, three times, five days a week after class to make their routines look effortless. From autumn football games to spring basketball season cheerleaders always promoted sportsmanship and goodwill. They often chanted a welcome cheer to the opposing team:

HEY, LET'S GO
LET'S GIVE A BIG HELLO
WE'RE HERE TO SAY
ENJOY YOUR STAY

H-E-L-L-O!

They also worked with the opposing team's cheerleaders to give each squad equal performing time during the game.

In a nutshell, cheerleaders got the spotlight and they got to wear those cute uniforms, not to mention getting to ride the bus with the team on game day. But they also worked very, very hard for the privilege. With countless practice hours logged, ability, agility, personality, drive, and a little luck, their dreams came true.

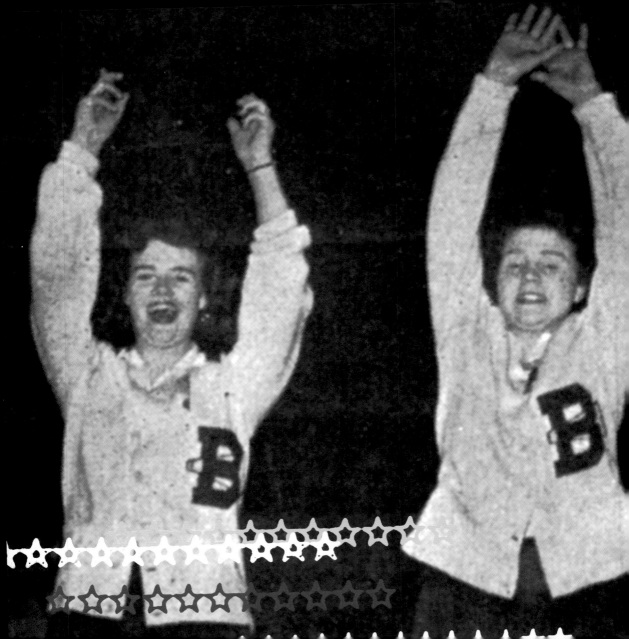

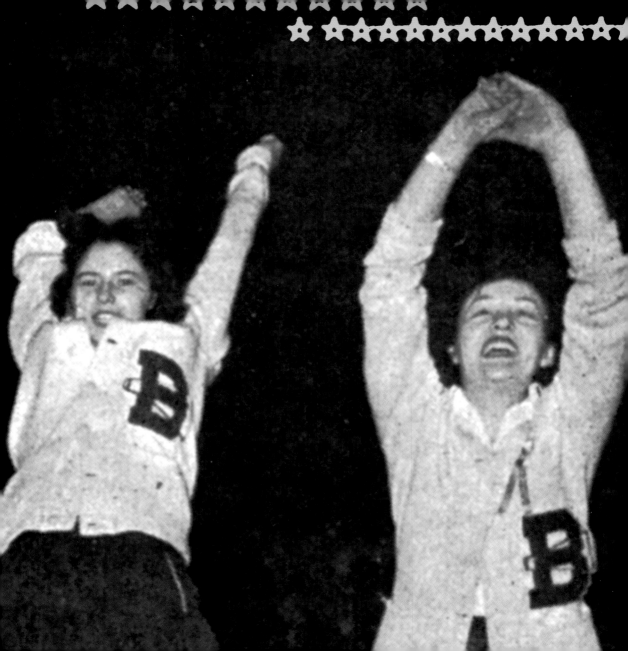

FAME AND GLORY

As Ruth Doan MacDougall wrote so eloquently in *The Cheerleader*, her 1973 coming-of-age novel about Snowy, a high-school cheerleader in the 1950s,

"Snowy learned that success meant the heady exhilaration of cheering on the polished gym floor, the yells seeming to swing the bright hot gym up and out into the night. And so her want was intensified. She wanted to be one of those fabulous Varsity cheerleaders cheering at a game that mattered, for the boys who mattered, the crowd caring passionately, and she herself one of those who led them."

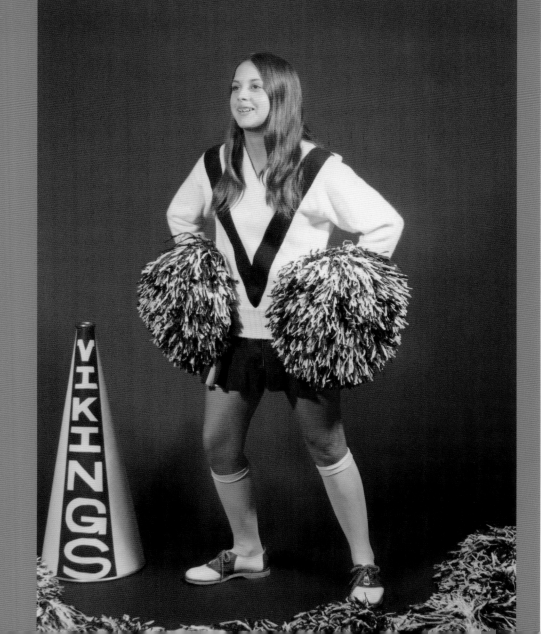

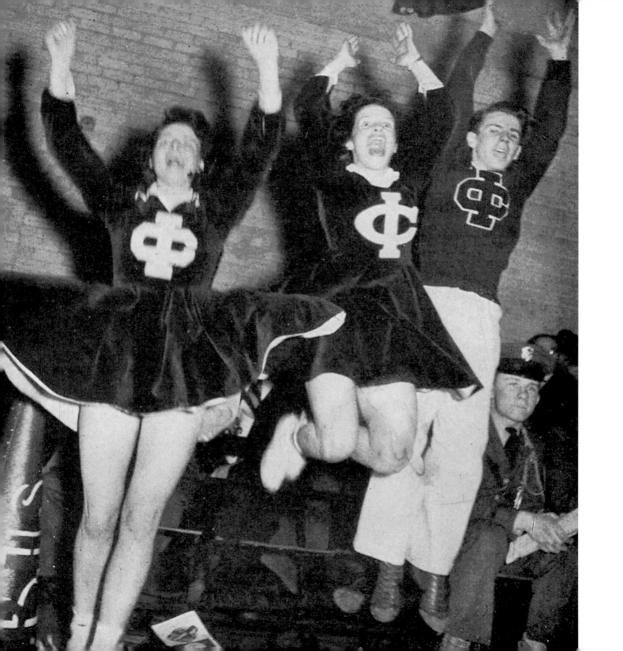

THE RIGHT STUFF

Back in the early 1970s *Cheerleading and Baton Twirling* summed up what it took to make the grade:

Cheerleading is leadership. Cheerleaders spark enthusiasm so that everyone is excited and involved with the action on the playing field. Skillful handling of a crowd is a big job. To do it well, a cheerleader must have a pleasing personality. She must be friendly and outgoing. People must like her too. Crowds will then want to respond to her directions. A girl who is not generally liked will not be able to handle a crowd. A girl who wants to be a cheerleader should have spirit. She should also be a good sport. All eyes are on her at every game. A cheerleader must be attractive. This does not mean that she must be a natural beauty, but she must make the most of what she has. Hair must be clean and shining and arranged in the most becoming way. Makeup, if used at all, should be applied sparingly. The well-scrubbed healthy looked is definitely the cheerleader look.

What about the figure? A girl who is overweight or skinny should certainly correct that figure fault before thinking of cheerleading. She should be of average height. A squad of cheerleaders who vary greatly in height or weight looks silly and is apt to be ineffective.

So far, the requirements mentioned have been those of leadership, spirit, appearance, health, and available time. But what about special abilities such as rhythm and good coordination? The answer is simple. Such talents are absolutely necessary.

A cheerleader must have rhythm so that cheers, chants and songs have the right tempo and beat. She must have coordination in arm movements and jumps to perform effective and well-timed cheers. She must be able to work with other girls as part of a coordinated team.

Being lithe and limber helps, too. A girl should be able to master the cartwheels and splits required of many cheerleaders. An incredible amount of exercise and practice will be needed by most girls. Agile tumbling tricks are not as easy as they look!

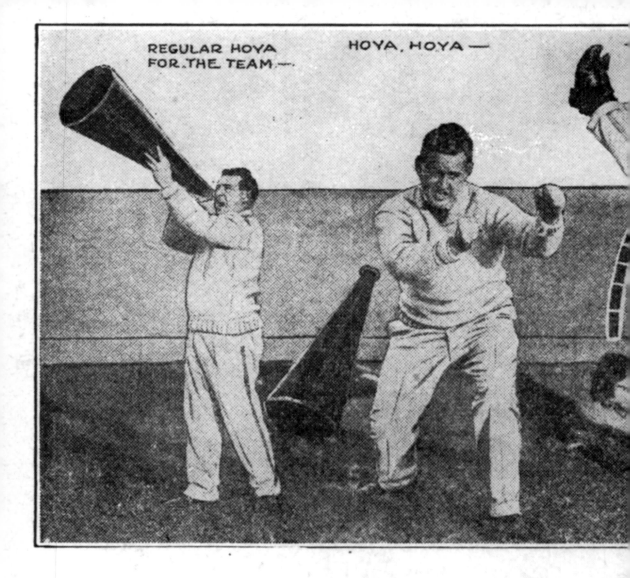

INTRODUCING JOHN BUCKLEY, OF
"HO

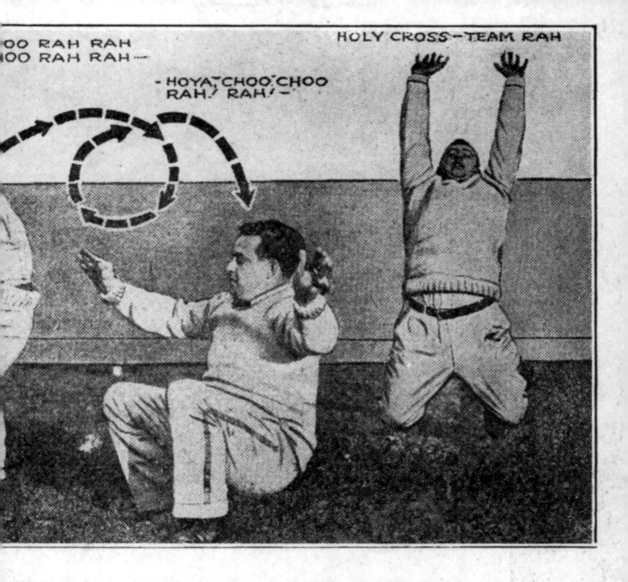

OO RAH RAH
HOO RAH RAH—

- HOYA CHOO CHOO
RAH! RAH!—

HOLY CROSS—TEAM RAH

CROSS COLLEGE, IN THEIR FAMOUS
YELL

HOW TO SELL A YELL

It's not enough just to know the words. All the texts, from the first published books on cheerleading to current manuals, stress the importance of technique. And practice, practice, practice. And the following:

1. *Use big, definite, wide, sweeping movements that can be seen from far away.*
2. *Always maintain contact with the crowd.*
3. *Finish each cheer with a final jump to cap it off with a flourish.*
4. *Show endless enthusiasm. All the time.*
5. *Have a repertoire chock full of a variety of yells to keep fans interested and entertained.*

ROCKING THE HOUSE, 1920s STYLE

The following cheers were published in *Just Yells*, the first cheer manual published. Back in 1927, George M. York pulled together a collection of the best high school and college yells from across the country. It's hard to imagine, but back in cheerleading's formative years, these cheers got the stadium rocking.

BOOMARACKA! BOOMARACKA!

BOOMARACKA RO!

SLIP, SLAP, SALLY MARIE—

HIPPA ZIPPA! HIPPA ZIPPA!

AIN'T WE GOT FUN!

HIPPA ZIPPA ZO!

SNIP, SNAP, ZIPPITY ZEE,

BOOMARACKA! HIPPA ZIPPA!

AIN'T WE GOT FUN!

FULL OF ZIP!

RAISE OUR VOICES, LET 'EM CHIME,

BLANKVILLE HIGH SCHOOL

WE ARE HAVING ONE GRAND TIME;

HIP, HIP, HIP HURRAH!

KLIP, KLOP, WOPPETY BANG,

WHERE'S THE BUNCH CAN BEAT OUR GANG?

AIN'T—WE—GOT—FUN!

POLLY, WOLLY, WOO!

RAH, RAH, RAH, RAH, RAH!

POLLY, WOLLY, WAY!

BLANKVILLE COLLEGE! (OR HIGH SCHOOL)

RAH, RAH, RAH!

RAH, RAH, RAH, RAH, RAH!

BIFFO, BIFFO, BIFFO, BING!

SOME CAN PLAY AND SOME CAN SING,

SOME CAN PREACH AND SOME CAN YELL,

RAH, RAH, RAH, RAH, RAH!

AND THAT MEANS US—WE YELL LIKE—OH, WELL,

LIKE EVERYTHING

FOR BLANKVILLE HIGH. RAH! RAH! RAH!

TEAM!
TEAM!
TEAM!

IT'S ALL ABOUT THE RHYME

Decades before rap hit the scene, cheerleaders were masters of rhyming in rhythm. *Just Yells* took care of the hard work by supplying the following to its readers. They suggest, if one couldn't find just the right word in the list below, that "a good rhyming dictionary should be secured."

READY? STEADY! WANT TO KNOW? LET'S GO! **AW S** raw, saw, shaw, straw, taw, thaw, yaw, and longer words with one of t tray, flay, fray, gray, gay, hay, jay, lay, may, nay, pay, play, ray, say, mar, par, tar, czar, scar, spar, star, char, afar, guitar, etc. **ARE SOUND** share, snare, spare, square, stare, beware, etc. **ER SOUND** cheer, drear, fear, gear, hear, sear, shear, smear, spear, tear, rear, year, ap etc. Also, be, he, me, we, she, sea, pea, plea, flea, lea, tea, key. **IE** sly, spry, sky, sty, tie, try, vie, why, ally, high, nigh, sigh, etc. **IRE S** brier, etc. **OO SOUND** coo, too, woo, taboo, undo, through, you, true, etc. **OR SOUND** or, for, nor, bore, tore, roar, sore, score, more, sh flour, sour, our, scour, bower, cower, flower, power, shower, tower, etc. bough, slough, thou, etc. **OW OR LONG OO SOUND** blow, tow, crow, tow, throw, trow, below, go, no, toe, foe, owe, wo, oh, so, lo, though, decoy, etc. (note: no destroy) **UR SOUND** blur, cur, bur, fur, slur,

craw, daw, law, chaw, claw, draw, flaw, gnaw, haw, jaw, maw, paw, syllables, such as withdraw. **AY SOUND** bay, bray, clay, day, dray, fay, , spray, slay, spay, stay, stray, sway, away, etc. **AR SOUND** car, far, jar, , dare, fare, hare, mare, pare, tare, rare, ware, blare, flare, glare, scare, jeer, leer, meer, peer, seer, sheer, sneer, steer, veer, ear, clear, dear, **EE SOUND** bee, fee, gree, glee, knee, see, three, tree, agree, decree, **D** by, buy, cry, die, dry, eye, fly, fry, fie, hie, lie, pie, ply, pry, rye, shy, dire, hire, ire, lyre, mire, quire, sire, spire, squire, wire, tire, crier, liar, strew, goo, etc. **OOR SOUND** boor, poor, moor, tour, pure, sure, your, , wore, yore, gore, oar, four, door, floor, adore, etc. **OUR SOUND** hour, **D** now, bow, how, mow, cow, brow, plow, row, sow, vow, prow, allow, glow, grow, know, low, mow, row, show, sow, strow, stow, slow, snow, go, etc. **OY SOUND** boy, buoy, coy, employ, cloy, joy, toy, alloy, annoy, ur, fir, sir, stir, etc. **URE SOUND** cure, pure, dure, lure, sure, allure, etc.

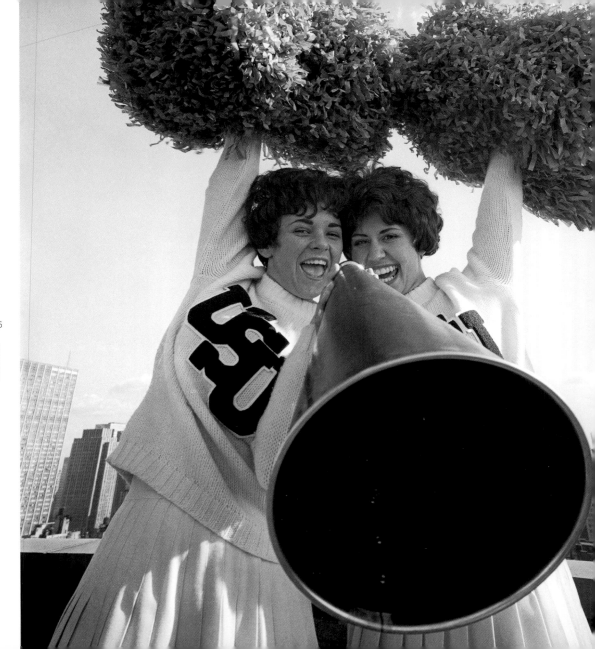

HEY, HEY, WHAT'D YOU SAY?

There's more to a good cheer than one would think. Whether it's a welcome shout, fight cheer, spirit yell, victory chant, or support song, each has a purpose and a place during the game. And as cheerleading evolved, a squad's repertoire of cheers expanded exponentially. Cheers became more complicated, they reflected musical styles of the times, and they responded more to real-time game action. Here are some crib notes on the different types of cheers:

CHANT—*a phrase like "we want a touchdown" or "de-fense" repeated over and over by fans*

ECHO YELL—*fans repeating back exactly what the cheer-leaders say*

LOCOMOTION—*a yell that starts slowly and builds up speed*

SOUND-EFFECTS YELL—*a siren, horn, or train whistle sound, added to a cheer for impact*

SPELL-OUT—*the old "give me an a . . . A"*

COLOR CHEER—*shouting out team colors*

SILENT YELL—*a cheer that consists of foot-stomping, hand-clapping, and noise-making, but no words*

RHYTHM YELL—*incorporating a funky beat; these were all the rage when jazz and blues hit the airwaves*

Beyond POM-PONS

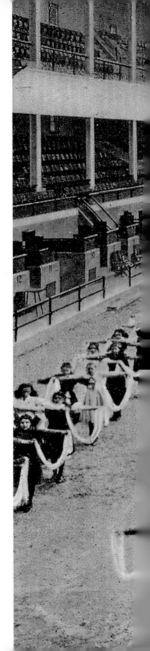

"As you plan clever, effective routines and stunts you subconsciously enhance your powers of originality and imagination. Yes, if you are gifted and talented, here, indeed, is a splendid chance to let the world know about it."
—Newt Loken, *Cheerleading and Marching Bands* (1945)

SO WHAT DID A GIRL DO IF THE SQUAD WASN'T IN HER FUTURE? Most likely she joined the drill team, kick squad, majorettes, marching band, or dance troupe. Whether down on the field, at a pep rally, or up in the bleachers, there were plenty of groups to help celebrate school spirit and support the team. Each group had a distinct identity and game-day function. Some groups were elected, some were made up of volunteers. Some responded to game action, some were pure, unabashed entertainment. And entertaining they were. In sparkling costumes, full of pomp and majesty, the girls made the field glitter even more brightly.

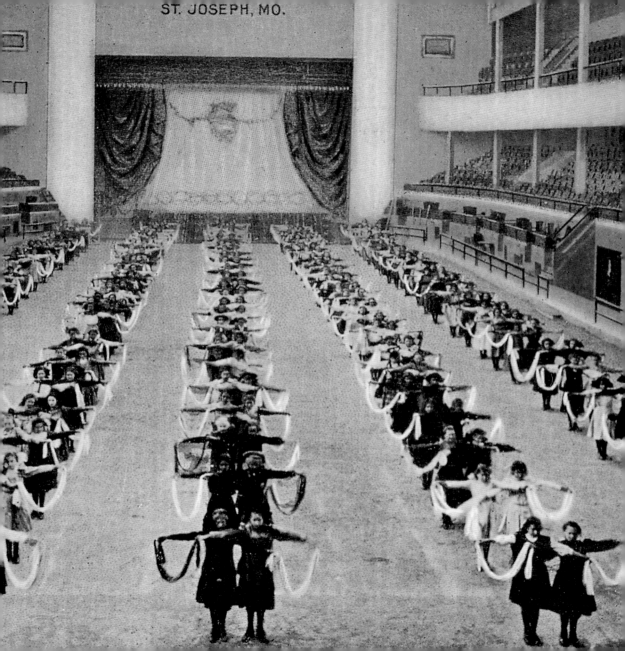

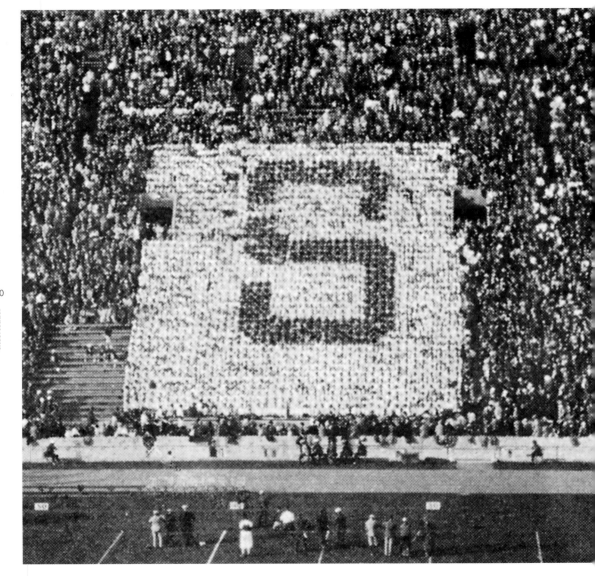

cheerleader

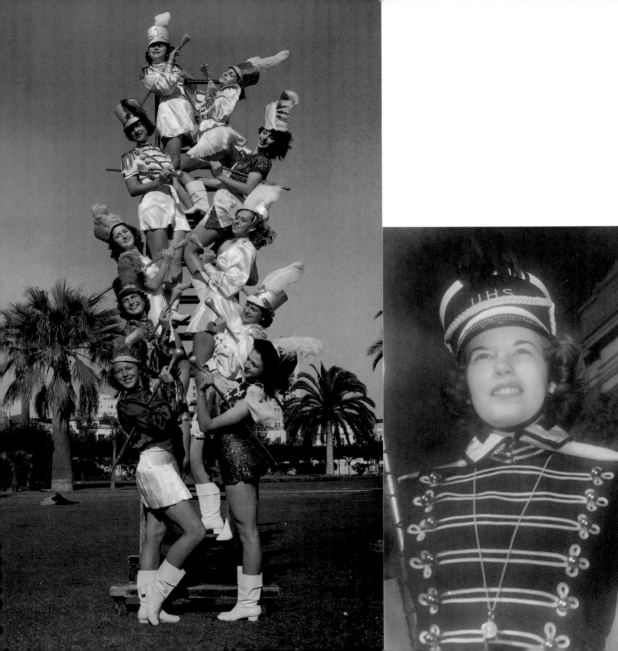

Some of the most visually arresting groups were flash-card rooter sections made up of thousands of fans (often up to twenty-five hundred), each supplied with a set of large colored cards. Sitting together in the bleachers, they flashed their cards—at their leader's direction—forming tremendous graphic images for all to admire. Lindley Bothwell, a cheerleader at Oregon State and then at the University of Southern California, took this entertaining feat a step farther. He trained his legions to change their cards quickly, creating images that seemed to move—early animation at its best.

In the 1920s, as school spirit and student participation were on the rise, pep squads, sometimes known as drill teams, came about. Comprising just a few girls or dozens of students, pep squads performed well-rehearsed routines, with dance steps or military-style marching formations. Some played bugles or drums, others carried wooden batons or flags. These inclusive groups provided larger numbers of students a chance to participate than a small cheerleading squad could accommodate.

By the 1930s, drum majorettes—girls with military-style uniforms, swingy short skirts, and high-stepping routines—were the focus of many a parade. No one is really sure how baton-twirling came about. Some say that European flag twirling was its inspiration. Others believe that drum majors, originally skilled male drummers in a marching band, who picked up a heavy baton and used it to keep time, were its origin. One thing is for sure: baton twirlers added glamour to marching bands and glitz to halftime entertainment. When the 1950s rolled around, organized camps for twirlers were the place to be. California Specialty Camps, started by Robert Olmstead, was the first camp of its kind and a majorette training must. Girls came out in droves to attend this high-profile camp and polish their twirls, throws, catches, spins, and marches.

If twirling wasn't quite the right fit, but performing with the band was appealing, there were always the song girls. Known as pom girls on the East Coast,

these girls don't actually sing. They used to sing along with marching bands, but as their highly choreographed pom-pon routines became more and more complex, they dropped the singing altogether. Although both song girls and cheerleaders use pom-pons, they've always been separate groups with different game-day functions. Cheerleaders respond to action on the field, and interact with fans in the stands, while song girls are straight-up entertainment.

If a girl wasn't interested in pom-pons or batons, she could always try out for the kickline. If you're not sure what a kickline is, that's okay. They're not nearly as popular as they were back in the 1940s. Imagine the Rockettes—a straight-as-an-arrow line of girls, standing hand to shoulder, counting off for the music to begin, then kicking their feet up toward the sky. It was those precision high kicks that set them apart from other performing groups. Eventually, the kicklines introduced dance moves into their routines and evolved into what we know today as dance teams.

Drill/dance teams, which first hit the field in the 1940s, performed elaborate and diverse routines. Some groups used poms, some carried flags, some kicked, and some danced. The Kilgore College Rangerettes were the groundbreakers in drill/dance performing. In 1940 Gussie Nell Davis, who founded the Rangerettes, created a diversion that kept fans glued to their seats during halftime. Her Rangerettes made their debut in 1940—their elaborately staged dance routines and short skirts were unlike anything seen on a football field before—and fans were smitten. The Tyler Junior College Apache Belles, another soon-to-be-renowned dance/drill troupe, hit the scene in the mid-1940s. They created quite a stir, wearing eye-catching costumes that played key parts in their routines. With fabulous hats firmly in place, capes twirling overhead, fringe flying, and boots stomping, these girls knew how to command the center stage, or center field. Both squads gained both national and international recognition through halftime performances and television appearances.

But let's not forget the boys! While very few joined the cheerleading or drill team squads, there was always plenty of room for them in marching bands. These bands have an illustrious history that dates back to the marching corps that accompanied legions of soldiers off to battle. Snare drums set the beat for marching men; often other instruments were added along the way to make the march a little more interesting. As new forms of music swept the country during the early twentieth century, marching bands fell out of favor, until the spectacle of halftime football shows provided them with an opportunity for making an eye-popping comeback. With majorettes high-stepping out in front performing snazzy routines and playing rousing tunes, marching bands bring music to the stadium and fans to their feet.

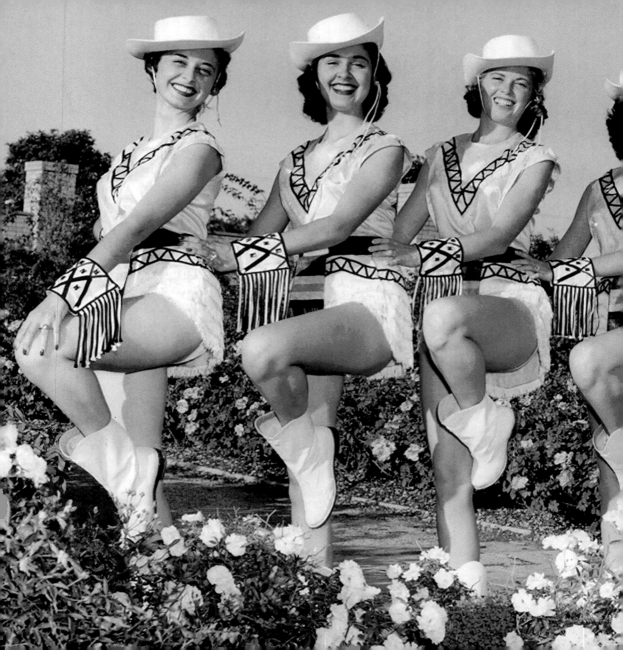

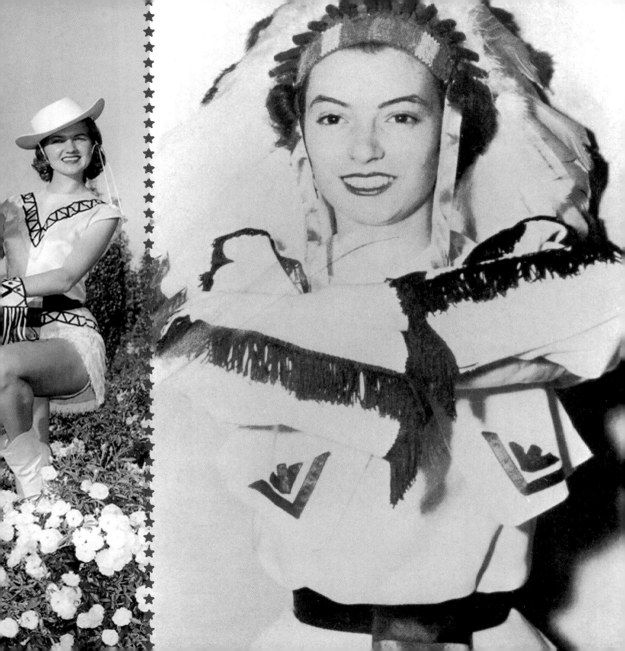

And what game-day festivities would be complete without a mascot? The first mascots were real animals. The student body took good care of their mascot, guarding it from marauding rival teams. Stealing another team's mascot before a big game was quite a tradition. But as sporting events grew to include entertainment as well as sport, costumed characters replaced animals and became all the rage. They performed amusing stunts and gags, replete with acrobatics, props, and hijinks, and kept the fans amused. Along with cheerleaders, mascots also responded to action on the field, leading the crowds in enthusiastic yells at a great play and frustrated groans at an unfortunate fumble.

And let's not forget the fans who fill the bleachers, crowd the stands, and give their all to the teams they support and the spirit groups who entertain them. Before TV and movies took over, football games were a major form of entertainment. Thousands of supporters would pour into local high school and college arenas to cheer on their team. A Saturday afternoon football game was the place to be and be seen, dressed in team colors, waving pennants, shouting into megaphones, binoculars in hand.

The avenues for spirit-minded fans were seemingly endless. If you were full of pep, enthusiasm, spirit, and cheer, there was generally a squad just waiting to welcome you. After all, who wouldn't want to be a part of game-day excitement—the rush, the roars, the cheers—not to mention the chance to be the center of attention? And while today many spirit groups still focus on school-based entertainment, others have evolved into competitive sports in their own right, together ensuring the ever-growing popularity of cheerleaders and their compatriots.

cheerleader

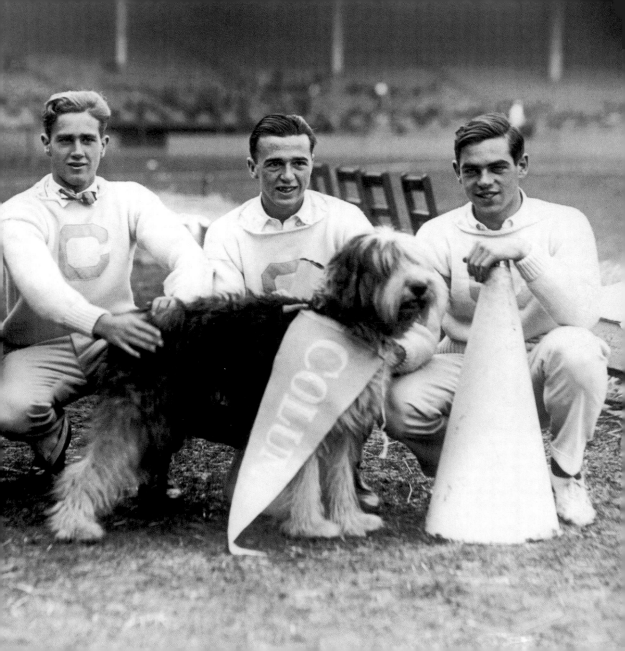

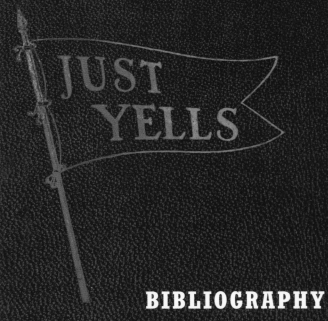

BIBLIOGRAPHY

THE WILLIS N. BUGBEE CO.
SYRACUSE, NEW YORK

"About NSG—A 50 year jump on the future!" www.nationalspirit.com/nsg/timeline/about.asp.

Davis, Roberta. *Cheerleading and Baton Twirling*. Connecticut: Weekly Reader Books, 1970.

Gonzales Jr., Arturo F. "The First College Cheer." *American Mercury* 83 (November 1956): 101.

Hanson, Mary Ellen. *Go! Fight! Win! Cheerleading in American Culture*. Bowling Green, Ohio: Bowling Green State University Popular Press, 1995.

Hawkins, John. *Texas Cheerleaders: The Spirit of America*. New York: St. Martin's Press, 1991.

Herkimer, Lawrence R. and Carol Pojezny. *Champion Cheers and Chants*. Dallas, Texas: The National Cheerleaders Association, 1979.

"History—Dallas Cowboys Cheerleaders." www.dallascowboys.com.

Humphrey, Marylou and Ron. *Cheerleading and Song Leading*. Vermont: Tuttle, 1970.

Lardner, Rex. "Herkimer Tells How to Make 'em Holler." *Sports Illustrated* 15 (November 27, 1961): 44.

"Let Us Sigh for the Silenced Yell." *The Literary Digest* 112 (January 2, 1932): 36.

Loken, Newt and Otis Dypwick. *Cheerleading and Marching Bands*. New York: A. S. Barnes, 1945.

MacDougall, Ruth Doan. *The Cheerleader*. New York: Putnam, 1973.

Neil, Randy. *The Official Pompon Girl's Handbook*. New York: St. Martin's, 1983.

Neil, Randy and Elaine Hart. *The Official Cheerleader's Handbook*. New York: Simon & Schuster, 1979.

"November Yells That Win Games." *The Literary Digest* 83 (November 8, 1924): 34.

"Organized Cheering." *The Nation* 92 (January 5, 1911): 5.

Pennington, Joyce. "History of Dance/ Drill Team: The First 20 Years, 1929–1950." www.dtda.org/insights/drill20.htm.

Pippey, Ralph. "Majorettes—You Just Have to Love Them." 2003. www.majorettes.ca/index.html.

Ryan, Pat. "Once It Was Only Sis—Boom— Bah!" *Sports Illustrated* (Volume 30, January 6, 1969): 44.

"Saddle Shoes—Synopsis." www.yesterdayland .com/popopedia/shows/fashion/fa1840.php.

Simmons, Jim. "Cram Course for Cheerleaders." *Seventeen* 32 (September 1973): 114.

"Sis—Boom—Ah! A Short History of the Art of Cheerleading." *Scholastic* 32 (March 1938): 39.

"Talk of the Town—Tiger." *The New Yorker* 28 (July 12, 1947): 18.

York, George M. and H. H. Clark. *Just Yells: A Guide for Cheer Leaders*. New York: Willis N. Bugbee, 1927.

cheerleader

pated in cheerleading. So I scoured eBay, did Internet search after Internet search, and hunted through flea markets. And then I began to panic. There just isn't a lot of cheerleading memorabilia out there. More than one dealer of vintage "paper" (ads, postcards, and the like) told me there were just far fewer cheerleading items produced than I imagined. And a former

ACKNOWLEDGMENTS

When I first started this project, I thought I'd contact the Cheerleading Museum (most likely to be found in Texas), gain access to their archive, and pieces would fall easily into place. But I soon discovered that there is no Cheerleading Museum. No cheerleading collections. No exhibits of cheerleading memorabilia to be found. How could that be? Cheerleading is so firmly entrenched in our culture—thousands upon thousands of men and women, boys and girls, have partici-

cheerleader put a second piece of the puzzle into place when she told me, "Cheerleaders just don't get rid of their stuff." But, slowly, sometimes excruciatingly so at times, wonderful items began to emerge. I took a deep breath and realized I could actually put this book together.

I started at the New York Public Library's picture collection and found some great vintage ads, along with photos from magazines and cheerleading books. Google (the best search engine out there) turned up cheerlead-

ing organizations; books, both recent and out-of-print, to track down; and site upon site featuring cheerleading's history. And, of course, there's eBay. For someone who loves to shop, it was the perfect way to find art for the book. Every few days I'd search under "vintage cheerleader," and amazing items would occasionally appear.

It was then that I realized how daunting the task of getting permission to use all this art would be. I started writing letters, calling organizations, sending out permission forms. I searched the Library of Congress and the U.S. Patent and Trademark Office for information. I spoke with publishers, printers, offices of various Secretaries of State, and corporate legal departments. Some queries garnered no reply, some offices (very few indeed) did not give permission, but most actually sent back a completed approval form (I got a thrill with every fax or letter). And then some people went well out of their way to help, with suggestions, ideas, and

support. This book would certainly not be possible without those kind souls who got a kick out of the concept of *Cheerleader*, wanted to participate, and I think at times took pity on me. My thanks to them all.

I would especially like to thank Jodi Davis, my editor at Chronicle, who gave me this wonderful book to do and whose suggestions and direction were exemplary. Many thanks as well to Benjamin Shaykin for his stunning design; to Carol Mann; Karen Kelly; to Deborah Gryder and Martha Elrod of the National Spirit Group; to Rhonda Roberts of the United Spirit Association; to Jon Merryman; to Scott Selheimer at the University of Delaware; to Lawrence Herkimer, Mary Ellen Hanson, Trina Robbins, and Jane Rogers of the Smithsonian; and to Jon Lichtenstein, whose input and advice I greatly appreciate. And to all the cheerleaders out there, whose spirit, past and present, motivated me to keep going.

123

CREDITS

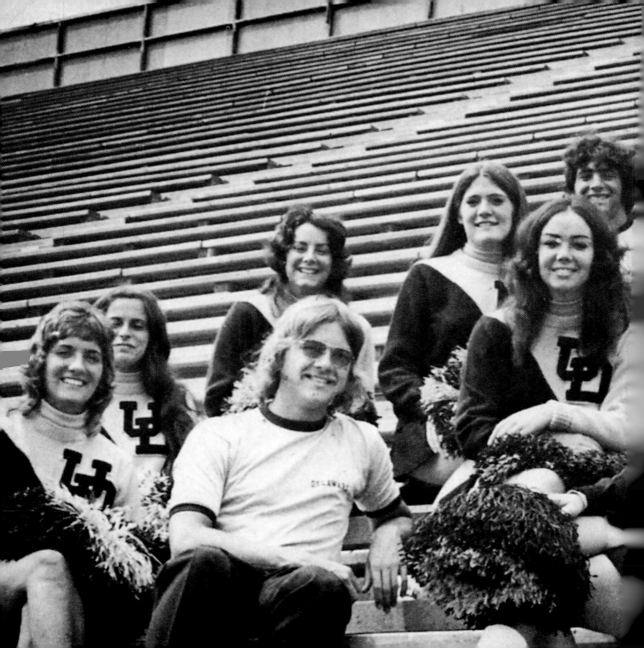

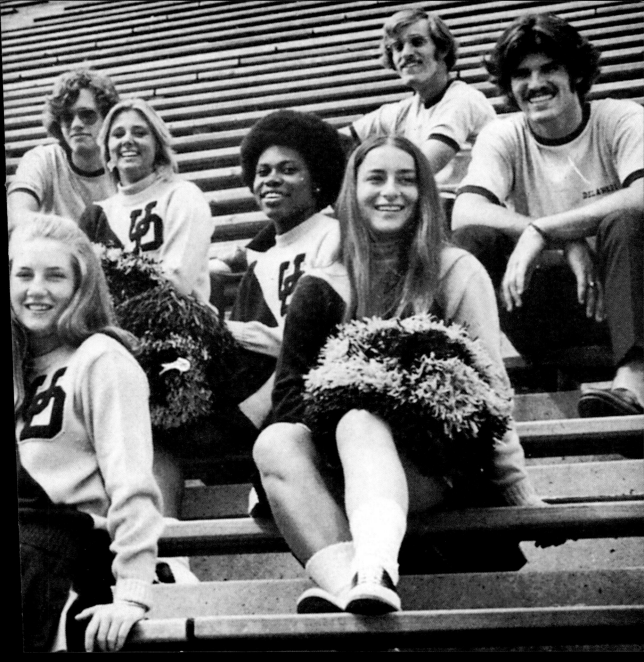

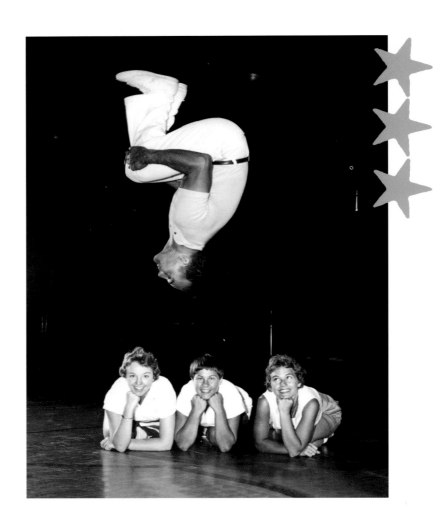